設計現場
Design on Location

不可不知的設計17招
Must-Know 17 Tips in Design

目錄 / Contents

序 / Preface

視覺設計 / Visual Design

包裝設計 / Packaging Design

插畫設計 / Illustration

序
Preface

Class of 2012
Department of Visual Design
National Kaohsiung Normal University

推薦序 / 思維工坊股份有限公司・Runewaker Entertainment

一群年輕設計師在最青春洋溢的時候，探索一個充滿想像和期待的世界，追逐一個屬於他們的夢想舞台。

並用各個創意作品寫下不同的故事和創作理念，讓更多人發現設計的創意，體驗生活的美感。

副總經理

推薦序 / 米蘭數位・Medialand

每年的畢業展來臨，總是抱著期待又怕受傷害的心情迎接，不斷被提醒著自己離當年畢業的日子越來越遠，當時許下的目標及夢想又經過一年是否達成，學生時期的朋友們現在過的好嗎？是否正在渡過人生不同階段，總是深深懷念著當年的充實！熱血！天真！體力無限的歲月，這就是你們送給我們的禮物，除了壓縮了四年學習而產生的精采作品外，最大的感觸莫過於此。

曾經受邀到貴校分享工作經驗，對我來說是個難忘的過程，高雄對我來說不近也不遠，是個相當有特色味道的地方，所孕育出來的學生們，從各位作品中就能看到對於設計的態度及認真。

人生成長像讀一本厚厚的書，大學畢業像把這本書讀完了開端，接下來的內容更是需要用心及專注去閱讀並持續學習，對各位社會新鮮人來說職場序曲才正要開始，不管將來是否從事相關領域的工作，請別忘了在校所學習的種種知識及當下的熱忱與目標，這些珍貴的寶藏將會成為你未來人生路上重要的動力來源。

祝福你們也歡迎你們來到下一個精采豐富刺激的人生階段.

設計長 Menzy.

熱愛且投身文創產業的人憑藉著的不外乎是一股傻勁與滿腔的創作熱情，殊不知做文創不是天馬行空的搞創作，「創作」事實上包含了「創意」與「實作」兩大層面。

現今面對來自世界各地的高手，我們非常迫切的需要具備實務工作能力與專業技術的優秀份子投入文創產業。我們非常樂見各大專院校紛紛開設了文創相關的系所，舉辦各項的競賽，由此可知這個產業日漸受到重視的程度。每每看到學生們的畢業製作，心中都不免發出讚嘆之聲，也不禁默默期許同學們在畢業進入職場後，能夠一本初衷的將創作的熱情與喜愛在工作上淋漓盡致的發揮。

總經理　施文祥

推薦序 / 摩鉅科技股份有限公司・Moregeek

遊戲產品與玩家的第一次接觸，通常建立在圖像上的印象。商品的包裝、海報、相關的輔宣品，乃至遊戲中的圖像設計與美術風格呈現　這些項目往往決定了玩家是否安裝一套遊戲或是登入到一個遊戲中遊玩的意願。而這部分最讓遊戲廠商傷透腦筋的問題無非是一大家的產品看起來就是那幾個樣子，因此在包裝與各類宣傳品的設計上要突顯出彼此的差異性也更加的困難，如果要分析當中的核心問題，就是產業中對於視覺傳達具有掌握力的人才並不足夠，因此在一開始的遊戲風格設計上，就沒辦法跳脫出既有的框架，而後更難在相似的產品中創造彼此的差異性。

對於高雄師範大學視覺設計系的畢業專刊能夠成為專書出版，個人認為這對於整個台灣的設計人才具有極大的正面意義，因為年輕的人才得到了一個發表的平台與窗口，而已經在業界的從業人員則能藉此機會，獲得年輕創意的洗禮與衝擊，這個出版品為業界與人才創造了一個彼此溝通的機會，為人才與人才間創造了一個彼此創意激盪的空間，這是過去台灣社會少有的，而也是台灣在設計能力上要能提升的關鍵所在。

沒有衝擊就沒有火花，是摩鉅科技堅信的理念，因此摩鉅科技一方面吸引資深的業界人才加入，同時也積極的搜尋具潛力的新血加入，藉由彼此的衝擊，創造更多樣多元的內容，但有了這本書刊的推出，我們可以有更多的衝擊機會，而這樣的影響所及也非只摩鉅科技一間公司受益，我相信這個開始會讓台灣有越來越多創意的種子發芽茁壯，進而提升未來台灣在全世界數位內容產業的競爭實力，期待各位讀者也能在此獲得啟發。

最後祝福即將由高雄師範大學視覺設計系畢業的同學，能在設計的路上找到適合自己發揮的方向，也期待在未來開發遊戲的旅程中有機會跟這些同學與本書的讀者們一起合作，讓我們一起推出更多具備國際級水準的遊戲產品到世界各地。

資深遊戲製作人

視覺設計
Visual Design

Class of 2012
Department of Visual Design
National Kaohsiung Normal University

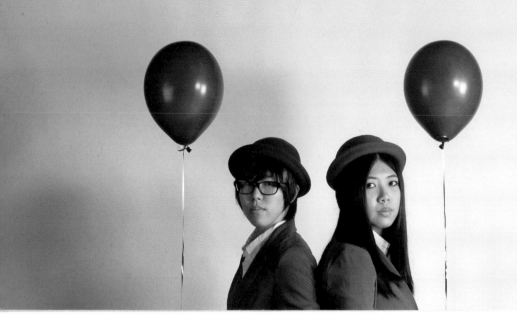

楊絮涵 / Shu-Han Yang

flickr.com/photos/jegn
jegn@livemail.tw

王靜雯 / Ching-Wen Wang

flickr.com/photos/braky1989
braky1989@hotmail.com

你願意説台語嗎？
認識台語的美好與智慧，就從俗諺開始。

Are you willing to speak Taiwanese?
To appreciate the beauty and wisdom of Taiwanese,
let's begin with Taiwanese proverbs.

● 視覺設計 Visual Design ● 團隊 Team

視覺設計
/不朽

Q：專題介紹

A：坐捷運時你身旁的帥哥或正妹操著流利的台語和朋友講電話時你覺得如何?俗氣?落伍?唉,這傢伙一定是南部來的。如果你有這樣的想法你就是我們的目標客群,察覺到現在的年輕人普遍認為台語落伍,所以即使會說,也不願意將它列為語言能力之一,我們以台語俗諺為發想點,發展一系列的商品,並以影像書做為主打,扭轉台語在大家心中既定的印象。

Q：製作此作品用的軟體是什麼,它如何將你們的設計發揮到極致?

A：Adobe Photoshop CS5。它能夠把拍好的素材去背,再運用圖層的特性,以及特效選單合成圖面,完成我們想像中的理想畫面,當然我們也會配合使用其他軟體,例如Adobe Illustrator CS5,我們將它使用在設計Logo的部分上,還有Adobe InDesign CS5,它是我們編書的好幫手。

Q：請談談你們如何克服創作上遇到的瓶頸,也給對設計有興趣的讀者們一些建議?

A：小綠:當做不出來的時候依然要努力嘗試,因為這是必經的成長與磨練,再於平時多做設計練習,往後遇到瓶頸的狀況就會改善。紅茶:首先,關掉電腦!然後做點家事,例如打掃房間,讓自己的腦袋先暫時忘記製作中的作品,經過休息就能突破瓶頸!

Q：請舉例最喜歡的雜誌或書籍編排,介紹一下吧?

A：大誌。它是一本對社會友善且有設計感的雜誌,在購買它時,便能立刻幫助販售它的遊民。裡面有很多關於「生活」的專欄,它告訴你「態度」。另外還有許多國際新聞,讓我們不只是一個台灣人,而是地球人。

Visual Design
/ BU XIU

Q : Project introduction.

A : How do you feel when you are on the MRT and hear a handsome guy (or a lovely girl) talking on the phone in fluent Taiwanese near you? Vulgar? Outdated? "Uh- huh, this guy must come from Southern Taiwan." If you do think so, then you are our target customers. We noticed that nowadays most teenagers think Taiwanese is old-fashioned. Even if they can speak, they are unwilling to take it as one of the language abilities. Taiwanese proverbs as the concept, we developed a series of cultural products. Graphic book as our feature, we will change your stereotype in Taiwanese.

Q : Which software did you use in this project? How did it help you bring out the best of your design?

A : Adobe Photoshop CS5. It has keying effects, layers effects and Layer Style to compose the images we wanted. Of course, we used others to assist the operation, such as Adobe Illustrator CS5 to design the logos; also Adobe InDesign CS5, a great tool for editing the book.

Q : Please tell us how you overcame the difficulties during the project and give some suggestions to the readers who are interested in design.

A : Green: " When you can't carry on your work, you should try harder. Obstacles are an inevitable part of training. After more practices of design, this kind of situation will be improved." Red: "First, turn off your computer, and do some housework. For example, cleaning the room could help you forget your work temporarily. After a while, you will be recuperated for more challenges."

Q : Please introduce your favorite layout style of magazines or books.

A : The Big Issue. It is a society-friendly magazine of creative ideas. When you purchase it, you are also helping the vagrant who sells it. It is full of the columns about life, and tells us the attitudes of life. Besides, it mentions the global news, helping us not only be a Taiwanese but also a part of this world.

畫面發展
/ Development of Images

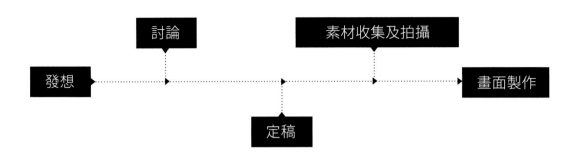

發想 → 討論 → 定稿 → 素材收集及拍攝 → 畫面製作

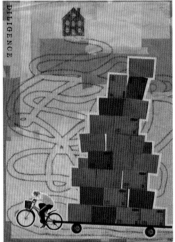

繪製草稿在畫面的形成中是非常重要的環節，草稿越完整便越有利於製作圖面，無論是素材的收集或是合成畫面都可以藉由好的草稿得到更完整的思考流程。

Making the draft is one of the important things when constructing images. If the draft is more complete, the images will be easier to make. Through a good draft, not only collecting material but making images could have more complete thinking process.

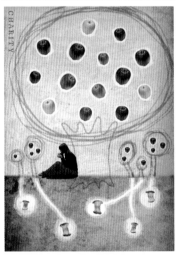

但草稿也不是一切，有時會在製作過程中蹦出更好的想法，所以隨時保持靈活的思考絕對是製作畫面時要時時注意的事。

But the draft is not all. Sometimes we will get better ideas during the process. So keep your thinking flexible is definitely an important thing when creating images.

裝禎過程
/ Process of Bookbinding

分印成小冊 / Print to Booklets

一個月份做成一個小冊，再以它為基準算出萬年曆需要的小冊數量，接著推算跨頁數量，並且排版，然後印刷成小冊。

Each booklet represents a month. Count the booklets needed to make the perpetual calendar. Calculate the numbers of double-pages and set up layout, then print out all the booklets.

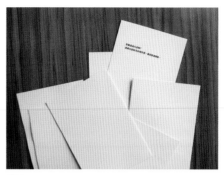

穿孔 / Punch the Holes

在每一本小冊的折合處用鉛筆畫出距離相同且適當數量的小點。例如：我們的萬年曆為A5大小，畫十個小洞較好，再用粗針或小鑽子穿過小點成為小洞。

Point the same distance and appropriate numbers of dots in the crease of every booklet. For example, our perpetual calendar size is A5, ten dots will be better. Then, use bodkin or awl to punch holes on every booklet.

縫線 / Sew the Booklets

選用不易斷裂且滑順的線，例如蠟線，再將每一本小冊利用科普特縫縫起來。

Choose the strong and smooth thread, for example, wax thread. Then, sew up these booklets with Coptic bookbinding.

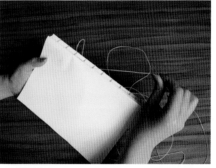

成冊 / Finish the Book

縫製完成後可自行選擇是否在書背塗上白膠增加強度，我們希望能在書籍增加手感，所以不上白膠，使用者可直接感受到線裝的觸感。

After sewing, you can choose whether to spread the glue on spine to secure the book. We hope it can have more texture, so we didn't use the glue. The user can directly feels the texture of the thread-bound book.

作品理念 / Concept

現在台灣社會上多數的年輕人已經不說台語,甚至認為台語俗氣又落伍,除了八點檔長壽劇外,也很少主動去接觸台語,我們希望能希望能藉由創新的影像將其平反,並把台語傳承到下一代,就從俗諺開始。

Many young Taiwanese in this generation are not willing to speak Taiwanese; they even think it is vulgar and outdated. We wish to revive it by designing novel graphics and pass it to the future generations. Let's begin with Taiwanese proverbs.

標誌 / Logo

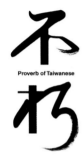

Proverb of Taiwanese

標準字是由幾何方塊和書法筆觸這兩個部分組成,幾何方塊在大眾的觀感是理性、具有現代感的,而書法筆觸則相反,通常是給人感性、古典的感覺,我們希望能融合這兩種意象,就像台語俗諺,不只存在過去,也是現代生活能學習的經驗。

The logo is composed by some geometries and calligraphy brushes. Geometry usually gives people a rational and modern feeling. On the contrary, calligraphy brushes give people the feeling of emotion and classic. We hope to fuse the two imageries, just like the Taiwanese proverbs, not only a past, but the experience we can learn now.

完成畫面 / Images

我們完成了十四張畫面,每一張都配合了一句俗諺及一項由天主教提出的七原罪及七美德。在畫面的表現我們採用拼貼的風格來製作,因為這種風格能融合不同的素材,可以用更靈活的方式去表達俗諺。

We create14 images. Every image combines a Taiwanese proverb and one of the Seven Deadly Sins or Seven Heavenly Virtues. We use collage to create the images, because in this way we can perfectly compose different materials in order to convey the proverbs in a more creative way.

影像書 / Image Book

分為七原罪及七美德兩冊，分別印有七張畫面及解說。封面採用黑與白這兩種對比色，並用厚磅的紙板增加重量感，書背的地方配合封面裱上白與黑的棉布，包裝則是採用原木色且不上漆的木盒以增加溫暖的觸感。

There are Seven Deadly Sins and Seven Heavenly Virtues, with 7 images and its commentary separately. As for the cover, we use black and white, the two contrasting colors; and thick carton board is used to increase texture. The spines are mounted with white and black cotton cloth. And we use a natural wooden box to be the package.

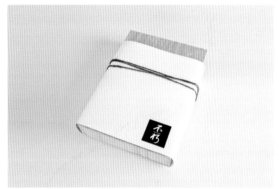

明信片 / Postcards

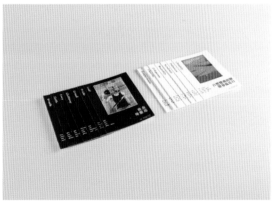

十四張印有畫面、俗諺及發音的明信片，希望將思念寄往遠方親友的同時，也能一併認識台語俗諺。

14 postcards with images, proverbs and pronunciations. When you send greetings to friends or family, they can also know the proverbs.

萬年曆 / Perpetual Calendar

行事曆是很多人生活中不可或缺的一部分，於是設計了這款萬年曆，讓台語俗諺能直接與生活並存。每一個月份都搭配了一張畫面及其說明，每一周則是有一句俗諺解釋，手工線裝方便書寫，以萬年曆的方法設計，可自行填寫月份及日期以避免空白頁的產生。

Calendar is an indispensible part in many people's life, so we design this perpetual calendar in which the Taiwanese proverbs could directly attach to life. Every month there are an image and its interpretation, and every week there is a proverb explanation. Thread-bound book is easy to write.
It is designed as a perpetual calendar which user can fill out the month and date. It can avoid wasting blank calendar papers.

周邊商品 / Merchandise

簡單且直接的行銷用品，希望能將「不朽」當成一個品牌經營，一個為台灣傳統文化努力，並帶來新意的品牌。

Simple and direct marketing products. We hope "Bu Xiu" could be a brand, a brand that endeavors to work for Taiwan's traditional culture and to bring new ideas.

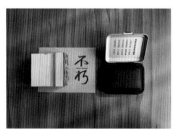
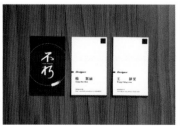
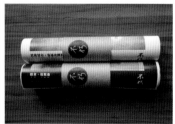

捨棄傳統大圖輸出的背板，改以木質為主的
色調，讓人感覺舒適並能以更安靜的心情接
收我們想傳達的意念。牆上貼有拍攝素材時
的照片。桌面則是放置麻布桌巾，作品整齊
排列在上方便翻閱，並提供名片及貼紙讓有
興趣的觀者索取。

Abandon traditional high resolution
render output; instead, we use original
wooden color. We want to make readers
feel comfortable, and with calm emotion
to receive the notions we want to
convey. The pictures on the wall were
taken when we collected the materials.
The table is covered with linen tablecloth,
and our products are placed orderly to
enable the reader to read easily. We also
provide some business cards and stickers
for those who are interested.

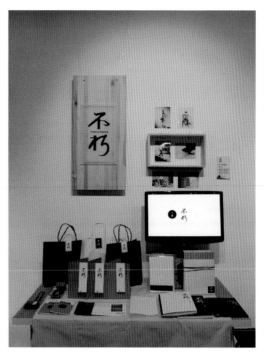

作品總覽 / All Products

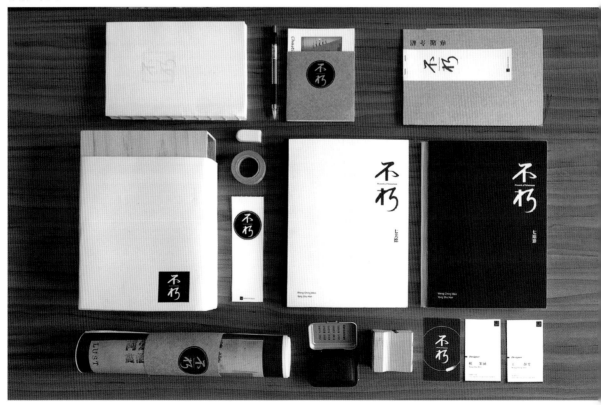

詹雯婷 / Wen-Ting Chan

flickr.com/photos/judysweety1026
judysweety1026@yahoo.com.tw

客家三祖=研究歷史文獻＋實地參訪＋
創意設計巧思＋三山國王有保庇。

Design of Lords of Three Mountains =
Research＋Observation＋Creativity＋Blessing.

● 視覺設計 Visual Design ● 個人 Individual

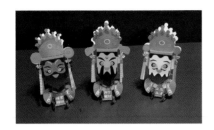

視覺設計
／客家三祖

Q：專題介紹

A：客家三祖＝研究歷史文獻＋實地參訪＋創意設計巧思＋
三山國王有保庇。
我是土生土長的客家人，我對客家文化的認知與研究深
感興趣，因此以客家三祖的形象設計作為主題並以客家
神明三山國王作介紹和一連串的設計。三山國王是客家
人的守護神，在台灣北中南都有三山國王廟，設計出整
體形象及周邊商品，讓台灣寶貴的文化創意產業能廣為
流傳。

Q：製作此作品用的軟體是什麼，它如何將你的設計發揮到
極致？

A：主要用Adobe Illustrator CS5向量軟體做出主要視覺、
客家三祖公仔造型與形象設計；以Adobe Photoshop
CS5合成公仔服裝；以Adobe Dreamweaver CS5製
作網頁；Adobe Flash Catalyst CS5用於輔助網頁動
畫製作；在建模方面，則是使用3ds Max與Maya等軟
體，影片製作則是以Final Cut Pro為主要製片工具。

Q：請談談你如何克服創作上遇到的瓶頸，也給對設計有興
趣的讀者們一些建議？

A：絞盡腦汁，試圖創作出有別於以往傳統客家特色的文化
創意商品。而我的靈感來源是，我是土生土長的客家
人，想為自己的家族做點貢獻。

Q：你有欣賞的設計師或藝術家嗎？他們對你的影響為何？

A：欣賞的設計師：John Jay，這位設計師說「如今，
速度已成為一種全新的技能，只把事情做好也許並不
夠。」我覺得他的想法深深影響著我，也許以後要學的
是設計能力，既有效率又能夠使自己的技能進步。

Visual Design
/ Hakka Three Ancestries

Q : Project introduction.

A : The Hakka Three Ancestries= study of historical
documents + field survey + creative design
ingenuity + Lords of Three Mountains blessing.
Due to my Hakka identity, I am interested in
it. Using Hakka gods as theme, I present the culture
and a series of designs. Lords of Three Mountains
are the patron saints of the Hakka communities
in the northern, central and southern Taiwan. The
image integration and merchandise design enable
Taiwan's precious Cultural and Creative Industry to
spread widely.

Q : Which software did you use in this project? How
did it help you bring out the best of your design?

A : I mostly used Adobe Illustrator CS5 to design the
main visual image and Hakka Three Ancestries
action figures; Adobe Dreamweaver CS5 to create
web pages; Adobe Photoshop CS5 to compose the
figure clothing; Adobe Flash Catalyst CS5 to assist
the web animation production. As for modeling, I
used 3ds Max and Maya software. Final Cut was the
major software used in film production.

Q : Please tell us how you overcame the difficulties
during the project and give some suggestions to
the readers who are interested in design.

A : Just beat the brains out, trying to create cultural
and creative goods that are different from the
traditional Hakka characteristics. The source of
inspiration: I am a native Hakka who wants to
contribute to the clan.

Q : Who is your favorite artist/designer? How does he/
her influence you?

A : I am a fan of John Jay. The designer once said,
"Speed is the new craft. Making things well may
not be enough anymore." I think his idea has a
profound impact on me. Perhaps in the future I
should work harder on designing ability as well as
enhancing the efficiency.

概念發展
/ Development of Ideas

三山國王是客家人的守護神，在台灣北中南都有三山國王廟，設計出整體形象及周邊商品，讓台灣寶貴的文化創意產業能廣為流傳。

Lords of Three Mountains are the tutelary gods of Taiwanese Hakka.
There are temples of Lords of Three Mountains all over Taiwan.
The design of overall image and merchandise help Taiwan's Cultural and Creative Industry to spread widely.

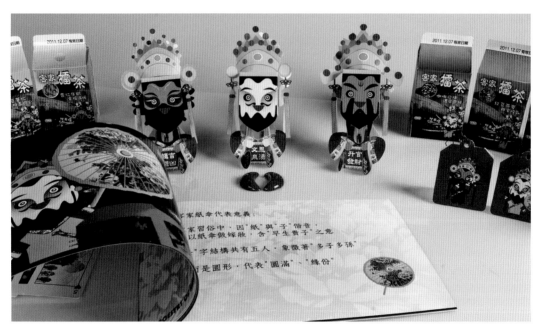

三山國王傳說故事
/ Fable Story

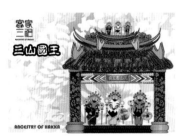

此設計是一本介紹客家神明三山國王的傳說故事書，以繪圖和文字說明表現出客家特色文化。

Introduce the Hakka gods, Lords of Three Mountains, with the characteristic Hakka culture.

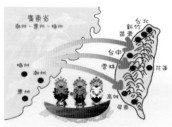

明朝末年鄭成功帶領廣東省潮州梅州跟惠州部將到台灣，為了抗清也從是墾殖。

The Ming Dynasty lead Guangdong Province army to reclaim Taiwan.

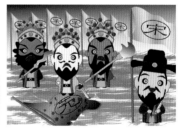

南宋末年宋昺帝當年在潮州被元兵追迫，忽然黑白紅臉三壯士現身，殺退元兵救了昺帝。

Three painted-face soldiers appeared to rescue the emperor.

三山國王為台灣付出許多貢獻，拓墾土地、建設等等。

They had contributed much for Taiwan, such as cultivation, construction and so on.

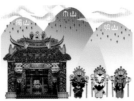

宋昺帝為了感謝三位神明的貢獻，因此封他們為「三山國王」。

Emperor Song conferred a title on them as the gratitude.

早期客家人以油桐樹作為經濟作物，因此成為客家文化象徵。

Hakka ancestors regarded the tung trees as the cash crops.

搭配藍衫的鞋子有繡花拖鞋和翹鞋兩種，以層層布料納縫而成。

Two kinds of curled shoes were made from cloths, sewed layer by layer.

六堆客家莊中盛開著繽紛花朵，均有特殊含義，稱為「客家九香」。

Each flourishing flower has a special meaning. They are called "the Hakka nine fragrances."

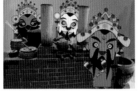

客家先民勞動活動多，吃得鹹又油是客家菜特色。

Due to the need for massive laboring, Hakka food is usually salty and greasy.

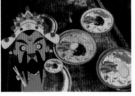

粄條是最具客家美食的代表，也就是台灣人俗稱的「粿仔條」。

Ban-tiauw is the most representative Hakka delicacy, also called "Gua-a-diauw".

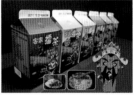

擂茶是客家人招待貴賓的茶點，「擂」是研磨之意。

Pounded tea, lei cha, is what Hakkas serve the guests. Lei means grinding.

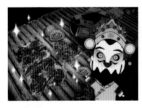

另一種特色客家小吃是粿類的紅龜粄、草仔粿和麻糬。

Another characteristic Hakka snack is the red turtle dumpling and ma-gi.

客家紙傘代表早生貴子象徵著多子多孫之意，故以做為嫁妝。

The paper umbrella represents much offspring. Therefore, it is used as a dowry.

藍衫是客家傳統上衣大多為藍或黑色，稱為客家藍衫。

The blue shirt is the Hakka traditional clothing.

標準色 / Color Plan

以大紅色作為介紹廟宇的主色，以紫色客家花布搭配底色，
表現出三山國王之神聖感受。

Bright red as the main color to introduce the temple.
Purple Hakka cotton print as the background,
representing the sacredness of Lords of Three Mountains.

● C 15 / M 100 / Y 90 / K 10

● C 30 / M 30 / K 100

標誌 / Logo

客家三祖是客家神明三山國王，以客家花布和廟宇的龍柱結
合在Logo上，展現客家的傳統精神和客家廟宇結合的美感。

The Hakka Three Ancestries are Lords of Three Mountains.
The logo combines the Hakka cotton print and the
Dragon Pillars in the temple, showing the Hakka spirit
and the aesthetic of the Hakka temples.

海報 / Poster

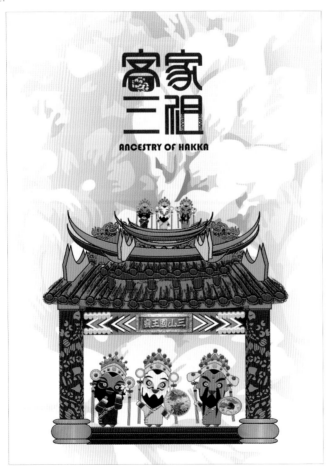

周邊商品 / Merchandise

以創意為出發點，環保為考量，將紙公仔模型畫成展開圖，將展開圖沿線剪下照著說明書的步驟，就能將平面的圖摺成立體的三山國王創意紙商品了，既環保又有設計感的紙做文化創意商品。

商品：三山國王點頭紙公仔、立體卡片三山國王廟、三山國王運勢籤、故事書、擂茶系列包裝、撲克牌。

Creativity as the starting point, the environmental protection as the consideration, I draw out the paper doll model pictures. By cutting down the picture and following the instructions, you can make the pictures into the creative 3D paper commodities.

Products: bobbing head paper dolls, 3D temple cards, the fortune lots, story book, beverage packaging, and playing cards.

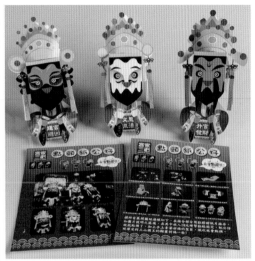

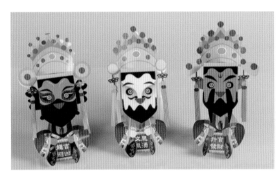

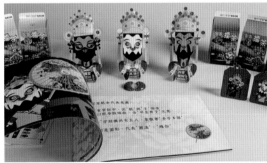

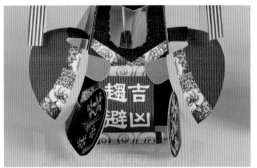

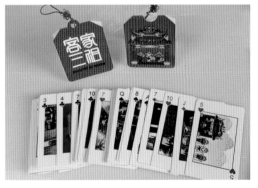

三山國王點頭紙公仔、傳說故事書、擂茶系列包裝、撲克牌。

Bobbing head paper dolls, story book , beverage packaging, and playing cards.

設計作品 Design Works　　視覺設計 Visual Design

點頭紙公仔製作介紹 / Instructions

1	2
3	4
5	6
7	8

1. 將展開圖沿線剪下
2. 按照黏貼處黏起
3. 將十元硬幣黏貼並固定
4. 尖端放在兩個白色圓點上
5. 地心引力將頭部前後搖
6. 將公仔拿的祈福聖旨黏合
7. 神帽正面與反面黏至頭上
8. 黏神袍後紙公仔就完成了

1. Cut the picture into pieces by the lines.
2. Glue it up part by part.
3. Put a 10 dollar coin in and secure it.
4. Attach the pointy part to the two white dots.
5. The gravity will pull the head and make it bob.
6. Glue the prayer sheet to the doll's hands.
7. Put the front hat and back hat on the doll's head.
8. Glue the gown on and it is done.

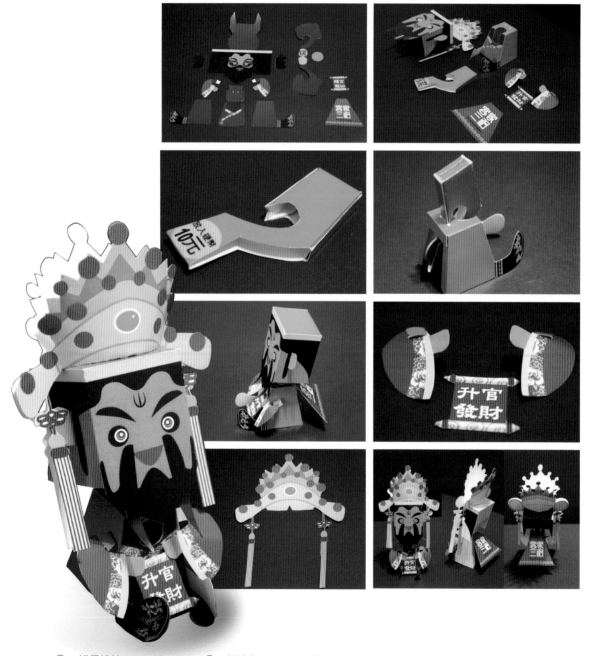

視覺設計 Visual Design 設計作品 Design Works

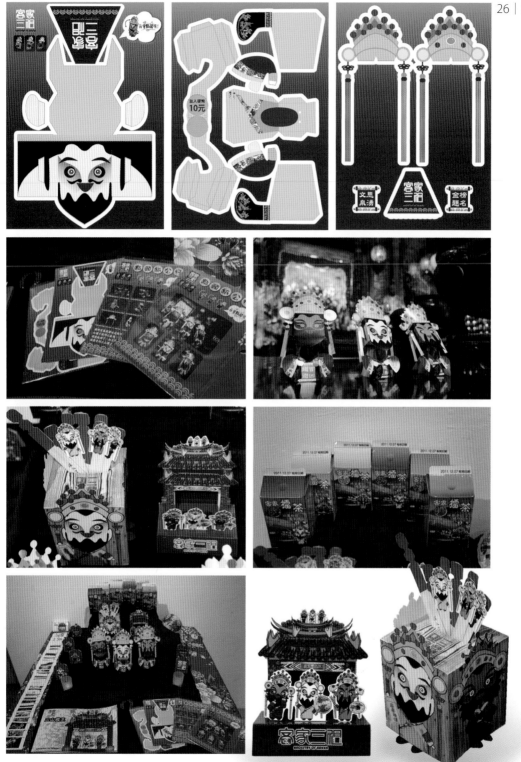

立體卡片三山國王廟、三山國王運勢籤。
3D temple cards and the fortune lots.

江秉穆/ Bing-Mu Chiang

flickr.com/photos/shadow790222
apparition790222@hotmail.com

曾安佳/ An-Jia Tzeng

flickr.com/photos/kay7975
kay7975@hotmail.com

STUDIO ARTIST

為亞提斯舞蹈工作室現階段做形象整合設計，
突顯教室最大特色。

Integrate the current image of STUDIO ARTIST,
highlighting the characteristics of the studio.

● 視覺設計 Visual Design ● 團隊 Team

視覺設計
/ STUDIO ARTIST

Q：專題介紹

A：由於我們想做的是實務設計，正好STUDIO ARTIST擁有完整的資訊與大量的資源可以運用，除了替教室重新設計形象外，也做了統整教室內容的網站平台，並發展多媒體、平面等周邊，最終欲突顯教室的三大理念：
Family：每一位成員都是家人。
Passion：隨時保持對跳舞的熱情。
Professional：不停止在舞蹈上的追求。

Q：製作此作品用的軟體是什麼，它如何將你們的設計發揮到極致？

A：Adobe Photoshop CS5跟Adobe Illustrator CS5包辦了所有影像的排版與處理，網站的部分使用的是Adobe Flash Catalyst CS5和Adobe Dreamwaver CS5。多媒體製作的部分剪輯使用Sony Vegas，後製使用Nuke，以上兩種軟體對於檔案格式的支援度和穩定度很高。3D作業上使用Autodesk Maya。

Q：請談談你們如何克服創作上遇到的瓶頸，也給對設計有興趣的讀者們一些建議？

A：實務設計與創作設計最大的不同就在於與業主溝通的過程，在滿足業主需求的同時也必須維持作品的水準與美感即是最大的挑戰。在製作上，最好能有多人意見參考，避免單一做法或太過主觀的想法。學習與別人合作是從事設計非常重要的課題。

Q：請介紹製作影片的過程，在你們的作品中最想與大家分享的是什麼？

A：前製工作的重要性，前製包括劇本撰寫、草稿分鏡、場勘、與表演者溝通等。在拍攝過程中要不斷去克服氣候或人事等等各種突發狀況，有突發狀況時就會顯示出前製作業的重要性，前製做的越足，應變能力也就越強。只要拍攝過程順利，在後製上就越省力。

Visual Design
/ STUDIO ARTIST

Q：Project introduction.

A：We aim towards the practical design. STUDIO ARTIST happens to have plentiful information and resources that we could make use of. In addition to designing a brand new set of images for the studio, we also create an Internet platform in which the contents of the studio are organized. Also we develop the peripheral media such as the printed and the multi media. Our final goal is to show the three key concepts of the studio:
Family: Every member is part of the big family.
Passion: To stay enthusiastic about dancing.
Professional: To keep pursuing the expertise of dancing.

Q：Which software did you use in this project? How did it help you bring out the best of your design?

A：Adobe Photoshop CS5 and Adobe Illustrator CS5 are the major software for all the image layouts. We used Adobe Flash Catalyst CS5 and Adobe Dreamwaver CS5 in making the website. The editing of multimedia was done with Sony Vegas; and Nuke for post-production. The last two software have high stability and support in different formats of files. Autodesk Maya was used in processing 3D projects.

Q：Please tell us how you overcame the difficulties during the project and give some suggestions to the readers who are interested in design.

A：The significant difference between practical design and creative design is the process of negotiating with the clients. The biggest challenge is how to satisfy their needs as well as maintain the standard and beauty of the projects. All opinions are welcomed to prevent excessive subjectivity. Learning to cooperate with others is an essential part in the designing field.

Q：Please tell us about the process of making movies, and to share in your work?

A：Pre-procedure is important, including composing the scripts, storyboard of the drafts, site survey, and communicating with the performers, etc. During the shooting, all kinds of unexpected situations are to overcome, such as weather or personnel matters. The more intact the pre-procedure, the stronger the adaptability to changes. So long as the shooting goes well, the post-production will be much easier.

影片剪輯
/ Movie Clip

Sony出品的Vegas Pro介面乾淨，雖然提不上專業剪輯軟體但是一般使用算是非常夠用了，Vegas有兩個很重要的優點，一個是目前還沒有遇到不支援的格式，包括各種廠牌的原生格式，另一個是Render可以調整的細項很多自由度非常高，穩定度就更不在話下，同時也支援一些寫給AE或其他調色軟體的外掛。

The interface of Vegas Pro, released by Sony, is easy to use. Although it is not as functional as professional editorial software, its functions are enough for general use. There are three advantages of Vegas Pro. One is that it supports all kinds of formats, including original formats of different companies. Another is its operations of rendering are specific and is able to be revised freely. The other is that it is stable, offering some plug-in software for AE or other color correctors.

影片後製
/ Video Post-Production

選擇使用The Foundry Nuke的原因有幾個，本身習慣使用node-base結構的軟體，node-base算是Nuke跟AE最大的不同，能夠使複雜的流程看起來很清楚，Nuke在調色跟合成通道上也有更大的自由，軟體本身的穩定度高運算速度也快不少，還有很重要的一點是Nuke提供三維空間，支援.fbx或.obj等通用三維格式，可以直接在後製軟體裡面進行三維合成。

The reasons we choose The Foundry Nuke are as follows: First, we are much more familiar with the node-base structure software. Node-base structure is the main difference between Nuke and AE. With this software, we could simplify the complicated process, making it much clearer. Second, we are freer to correct colors and compose channels. Third, Nuke is stable and its render speed is faster than AE. The most important thing is that Nuke offers 3D; supporting universal 3D formats such as .fbx, .obj and etc. We can do 3D composition in after effect software directly.

三維模擬
/ Three-dimensional Simulation

在三維模擬的部分使用了Autodesk的Maya，比較特別的是因為是做室內模擬，所以換了Vray來做彩現的部分，Vray可以很好的搭配Maya原本的燈光跟材質，又提供了幾種非常方便的材質，IES燈光的自由度也很高，光跡追蹤、焦散、全局照明等的搭配使用方便，可以較輕鬆創造擬真的彩現效果。

In 3D simulation part, we utilize Maya of Autodesk. Something special is that we use Vray instead of Maya software or mental ray for the rendering part for the sake of indoor simulation. Vray matches well with original light and material of Maya; it offers other kinds of materials as well. Moreover, the light degree of IES is high. Because the matching uses of ray trace, caustic and GI are convenient, we can create simulation of rendering in an easy way.

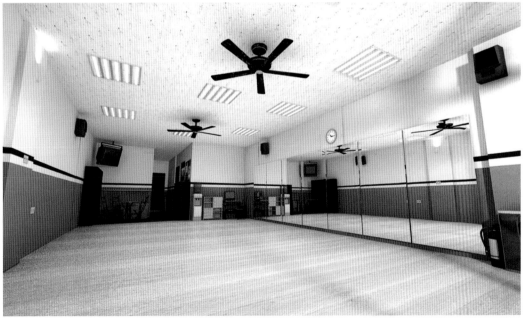

標準色 / Color Plan

橘色的運用是沿用過去教室的主色調。
The use of orange is the main color also used in the previous studio.

● C 10 / M 70 / Y 95

● K 80

標誌與標準字 / Logo

Logo的設計，從STUDIO ARTIST的開頭簡寫衍伸，在突顯教室特色的原則下，發展出兩個舞動的A環繞S的專業意象，為了跳脫傳統街頭塗鴉感的教室形象，而給予了俐落的幾何造型，圓潤的外型則代表著亞提斯就像個大家庭。

The design of logo is derived from STUDIO ARTIST at the beginning of shorthand. Develop the professional image of the two dancing A surrounding S under the principles of the studio characteristics. In order to depart from the traditional graffiti images of typical studios, we present a neat geometric model. The round shape represents that STUDIO ARTIST is like a big family.

教室老師形象照 / Image of the Studio Teachers

周邊商品 / Merchandise

在周邊產品的製作上，以符合實用需求為目的做發想。
The purpose of the merchandise is to meet with the practical use.

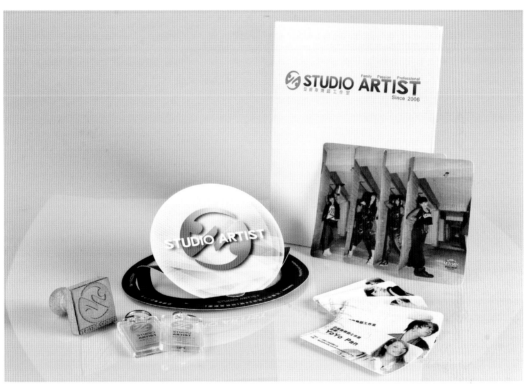

資料本 / Manual

除了網頁統整資料之外，教室平日對外也需要一份紙本來做介紹。

In addition to integrating the website information, the studio also needs introduction pamphlets.

展示紀念DM / Display and Commemoration of the DM

用圓形的設計來貫徹教室理念，加上互動式的結構，讓拿到DM的學生在閱讀完資訊後能自己動手組裝，達到展示功能，極具收藏價值。

Circular design implements the concept of the studio, coupled with the interactive structure, so that students get the DM after reading information can assemble themselves to achieve the display function, and valuable for collection.

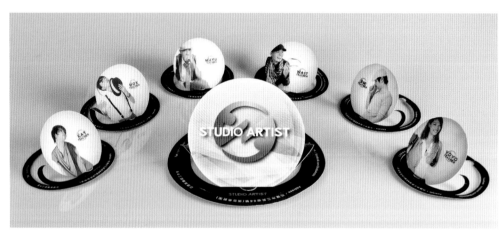

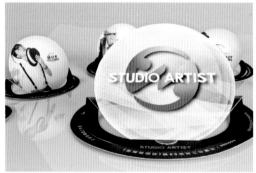

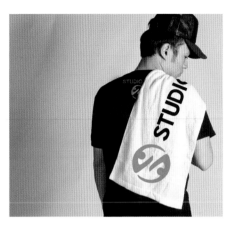

帽子與毛巾 / Hat and Towel

帽子與毛巾是舞者不可或缺的配備,設計風格簡單大方,建立教室的品牌形象。

Hats and towels are indispensable for dancers. Simple and elegant, the design establishes the brand image of the studio.

T恤 / T-shirt

T恤基本款重點是在突顯Logo,紀念版則加上一點巧思,供學生收藏。

The focus of T-shirts is to highlight the logo.

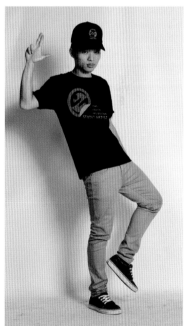

劉醇涵 / Chun-Han Liou

flickr.com/photos/hanliou
hanliou@hotmail.com

讓黑夜裡那一點一點微弱的光芒，
喚醒心底那一點一點流失的感動。

Let the faint lights in the night awake the losing emotions of the heart.

視覺設計 Visual Design　　個人 Individual

視覺設計
/光年

Q：專題介紹

A：有多久，我們不曾抬頭仰望天空？
光年天文館，帶領人們探索神秘的星空，讓黑夜裡那一點一點微弱的光芒，喚醒我們心底那一點一點流失的感動吧。

Q：製作此作品用的軟體是什麼，它如何將你的設計發揮到極致？

A：主要使用Adobe Illustrator CS5和Adobe Photoshop CS5這兩種類型的軟體，使用上操作簡單且方便迅速，在作品想法的實踐上給了我非常大的幫助。
Adobe Illustrator CS5－能夠在作品的製作上有效率地繪出向量的造型圖案。
Adobe Photoshop CS5－可編輯圖片檔案，在作品的製作上發揮修飾、美化圖檔的功能。

Q：請談談你如何克服創作上遇到的瓶頸，也給對設計有興趣的讀者們一些建議？

A：設計的創作上，不可避免會經歷困難與挫折，難免一試再試之後卻達不到期許的效果。
當盡力的思索可以解決問題的資料及辦法之後，卻仍然無法離開創作的瓶頸時，我會先讓自己出外散步，在腦中的思緒沉澱過後，問題點會變得清楚，偶爾也會有不同的新想法出現呢。

Q：你有欣賞的設計師或藝術家嗎？他們對你的影響為何？

A：有，不止限於平面設計。一件好的設計作品都是設計師發揮巧思設計的。作品呈現的創意及背後的流程，如何發想以及創作精神，都是值得讓人去了解學習的。

Visual Design
/ Light-Year

Q：Project introduction.

A：How long have we not looked up the starry sky? The Light-Year Planetarium leads us to explore the mysterious starlit night. Let the dim starlight awakens and touches the deep down of our heart.

Q：Which software did you use in this project? How did it help you bring out the best of your design?

A：Mostly Adobe Illustrator CS5 and Adobe Photoshop CS5. They are easy to operate, saving a lot of time. They also help me greatly on putting the ideas into practice.
Adobe Illustrator CS5 — to draw the vector shape patterns efficiently in the production.
Adobe Photoshop CS5 — to edit picture archives, also serve the functions of modifying and beautifying the works.

Q：Please tell us how you overcame the difficulties during the project and give some suggestions to the readers who are interested in design.

A：Inevitably, there will be difficulties and setbacks in the process of design. And sometimes it couldn't meet the expectation even after a few tries. After trying to gather as much information and methods to the problem, if I still couldn't solve the obstacle, I would just go out for a walk. Let the brain calm down, then the crux would appear. I might even come up with new ideas!

Q：Do you have any favorite artist/designer? How does he/her influence you?

A：Not just graphic design, any good work is created by the ingenious designer. The work represents what is behind the creating process, the ideas and spirit. These are worthy of us to understand and to learn.

企業形象識別系統
/ Corporate Identity System

即有計畫的將企業特色主動向社會大眾傳播，使大眾對其企業有標準化的認識，在競爭市場中脫穎而出所制定的策略，進而讓消費者留下良好的印象。

企業形象設計分為三個方面：
1. 企業理念識別（MI）
2. 企業行為識別（BI）
3. 企業視覺識別（VI）
其中在企業形象識別的視覺識別方面與視覺設計息息相關。

Promote the business characteristics to the community with active plans, leading to public enterprises, policies that make enterprises stand out in competition. Furthermore, it leaves the good impression to the consumers.

Corporate image design is divided into three aspects:

1. Corporate Philosophy Identification (MI)
2. Corporate Behavior Identification (BI)
3. Corporate Visual Identification (VI)

Visual Identification of the corporate identity and visual design are closely related.

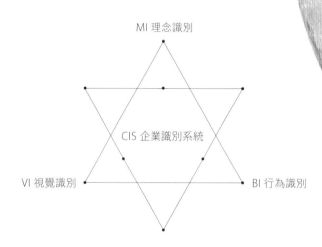

MI 理念識別

CIS 企業識別系統

VI 視覺識別　　　　　　　　　　BI 行為識別

企業視覺識別
/ Visual Identification

企業視覺識別包括基本系統、輔助系統、應用系統。基本設計要素包括了企業標誌、中英文標準字、標準色為主要核心；輔助系統包括輔助字體、輔助色彩；應用系統則是包括了周邊商品、企業用品等。

CIS includes the basic system and auxiliary system. Basic design elements, including logo, font and color, are the core. Auxiliary system includes the auxiliary font and color. Applications contain merchandise and enterprise products.

標誌 / Logo

標誌如同星光閃爍一般，在黑夜中綻放光芒。主要使用間隔的線段做為主要元素，傳達光線通過的意象。

Like a shining star, blooming in the night light. Using interrupted line as the main element, it conveys the image of light passing through.

標準色 / Color Plan

黑夜的宇宙黑，月球的月光黃，兩種標準色加上灰色輔助色組成光年的標準色。

Universe black and moon yellow, along with the auxiliary color grey, compose the color plan of Planetarium.

● C 40 / K 100

C 5 / M 5 / Y 30

K 30

標準字 / Font

利用星座的點與線段為元素，融合光通過般間段的線段，成為光年的企業標準字。

Constellation points of a line segment is an element, with the fusion of light passing through a break line, become the standard font of the Light-Year Planetarium.

ABCDEFGHIJKLM
NOPQRSTUVWXYZ
abcdefghijklmn
opqrstuvwxyz

光年天文台名片 / Planetarium Business Card

天文館名片紙張材質採用具有透光特色的描圖紙作為名片材質，以此特點表現出星光的微弱光線所發出的光芒感與穿透感。

Light-Year Planetarium uses thick tracing paper for your business cards; Star light brings a feeling of rays and penetration.

光年天文台簡介 / Planetarium Manual

天文館簡介紙質採用具有銀白色光澤的紙張，當翻閱天文館簡介的書頁時，字裡行間會隱隱約約透露出銀河般微弱的光芒。

Use the glossy silver-white papers as the material. When reading the manual, there will be faint rays between the lines.

光年天文台星座盤 / Light-Year Planetarium Planisphere

光年星座盤利用幾何的圓和方為視覺元素。星點表面塗以夜光漆，在觀察星象的夜晚也能輕易辨識星座的排列。

Light-Year planisphere uses simple geometric shapes of round and square as visual elements. The star points of the surface are coated with luminous paint. You can easily identify the constellation arrangement when you are observing the stars.

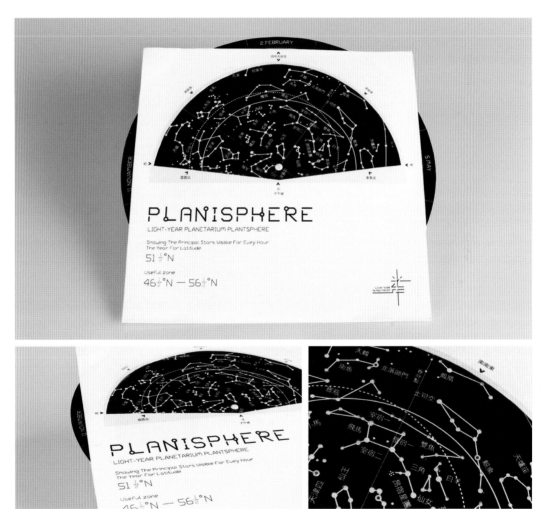

太陽系手冊 / The Solar System Manual

太陽系依序包含：水星、金星、地球、火星、木星、土星、天王星、海王星這八大行星。在太陽系手冊中可以了解太陽以及各行星的特色及觀測方式。

The solar system contains eight planets: Mercury, Venus, Earth, Mars, Jupiter, Saturn, Uranus and Neptune. You can learn the characteristics and observing methods of the solar system in the manual.

指示標誌 / Pictogram

利用星座點與點連線之中的點與線為元素，融合以光通過而間隔的線段，組合成具有光年天文館特色的指示標誌。

Use the dots and lines between the constellation points and their connection as elements. Integrate with the discontinuous segments of passing light to compose the unique pictogram.

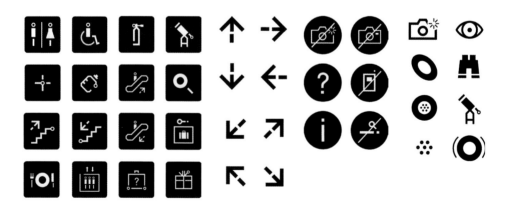

海報 / Poster

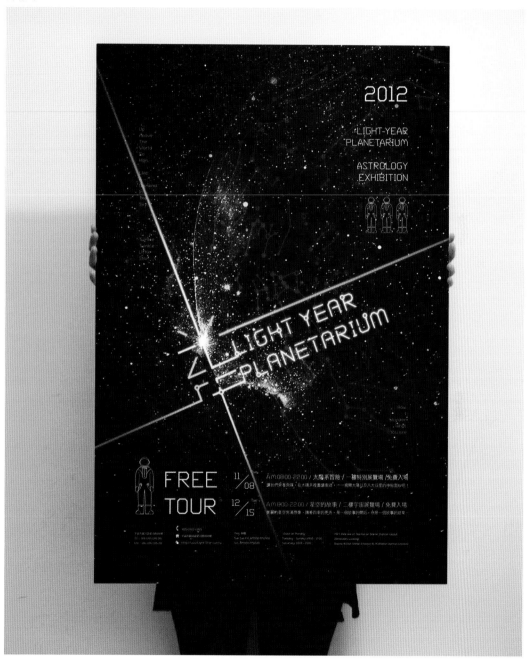

陳　琳 / Lin Chen

flickr.com/photos/lynn10545
lynn10545@hotmail.com

朱冠蓁 / Guan-Zhen Zhu

flickr.com/photos/toseman
toseman_inside@hotmail.com

交換旅行

她，想來場深度旅行，從過程中探尋自我；
他，心嚮往一個地方，卻被現實絆住了腳。

We combine one's mobility with the other's touching story,
making them help each other to fulfil their dreams.
And just wait for the other gorgeous shoe to drop.

● 視覺設計 Visual Design　● 團隊 Team

視覺設計
/ 交換旅行

Q：專題介紹

A：夢想到某個地方卻無法，生不如死；膚淺旅遊走馬看花，要死不活。
你受夠了沒？
一方提供故事一方提供行動力，來場交換旅行的冒險。

Q：製作此作品用的軟體是什麼，它如何將你們的設計發揮到極致？

A：Adobe Photoshop CS5、Adobe Illustrator CS5、Adobe After Effect CS5、Adobe Flash Catalyst CS5，想得到的大概都有。有明確目標與概念，才不會如同騎著小毛驢去趕集，摔得一身泥。

Q：請談談你們如何克服創作上遇到的瓶頸，也給對設計有興趣的讀者們一些建議？

A：網拍不會賣靈感，所以快關掉視窗！

Q：從事設計時，有沒有難以自拔的習慣，如何發現修正？

A：你會很容易餓，很情緒化，手頭有時也會很緊。堅持很難，但總會有個小奇蹟適時發生讓你寧可繼續闖下去。永遠，永遠不要去修正那份熱情。

Q：平時如何培養美感，發掘靈感？

A：出門找他，通常在書店、荒野，或海邊。找到後叫他先回家等你。

Visual Design
/ Exchange Trip

Q：Project introduction.

A：A superficial trip can kill a wayfarer. The idea we called "Exchange Trip" is about providing someone's touching story, a place that is too hard to reach for him. We combined one's motion strength with one's wish to make both dreams come true.

Q：Which software did you use in this project? How did it help you bring out the best of your design?

A：Adobe Photoshop CS5, Adobe Illustrator CS5, Adobe After Effect CS5 and Adobe Flash Catalyst CS5, basically everything you can think of. But without a clear concept, they are plain useless.

Q：Please tell us how you overcame the difficulties during the project and give some suggestions to the readers who are interested in design.

A：Online shopping websites won't sell you any ideas, so just shut them down!

Q：Do you have any habits that are so hard to quit when you are designing? How would you alter it?

A：You'll be hungry, moody, and out of cash sometimes. It might be hard to hold it on, but keep in mind that miracles do happen. Never ever alter your enthusiastic attitude.

Q：How to cultivate the sense of beauty and explore the inspiration in daily life?

A：Go out to look for it. It is usually hidden in bookstores, lawns, or beaches. Once you find it, make it come home and wait.

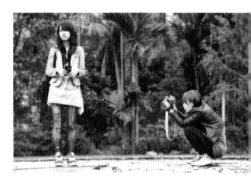

有個想法
/ One Simple Idea

有人，不甘旅行只是走馬看花。
提著相機與紀念品，卻帶不回一個故事；
有人，一輩子嚮往著一個地方。
現實卻有太多阻礙，願望總在咫尺天涯。

交換旅行是個小想法，
由無法遠行的人提供故事及願望，讓渴求深度旅行的旅人執行。

Some people are not content with the cursory travel.
Carrying cameras and souvenirs, but not a story.
Some people yearn for a place all of their life time.
Reality places too many obstacles to keep the wishes distant.

Exchange Trip is just a small idea.
People who cannot travel provide stories and wishes, and the travelers fulfill the execution.

Exchange trip

● 視覺設計 Visual Design　　● 製作過程 Production Process

午后小確幸
/ An Afternoon Trip

午后，女孩帶著交換旅行，小探險。

She goes on a little adventure with
Exchange Trip in one tranquil afternoon.

淺冬眠Slow Sleep / The Film

微電影。失戀後的女孩，像無法墜落的棉絮，四處飄盪。
帶著相機，四處旅行。卻無法屬於任何地方。
最後透過交換旅行計畫，帶著一個曾經也失去愛情的男
孩的委託，來到台東一個小車站，幫他清除曾經在此留
下的悲傷留言。
山里站，口耳相傳到不了的車站。在這裡被遺失的，尋
回後仍在閃爍。

The film, Slow Sleep, is talking about a heart-broken
girl who is hurt by love, tries everything to forget the
pain but in vain. Because of Exchange Trip, she meets
a guy, who lost his lover years ago. She helps him go
to a small train station in Taitung, cleaning up the
sorrowful messages he left.

淺 slow
冬眠 sleep

produced by
Exchange Trip

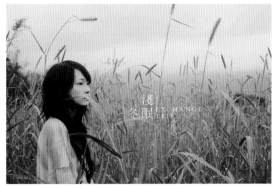

淺冬眠 EXCHANGE TRIP

製作過程 Production Process ● 視覺設計 Visual Design ●

履人 / Read It

履人，旅行與履行之人。交換旅行便是場履行夢想的小冒險。
四本季刊，每季分享一篇交換旅行的故事，並從中延伸單元。親情、友情、愛情、寵物親暱，一樣不少。

Zines about stories with Exchange Trip. Exchange Trip is the adventure fulfilling the dreams.
We sort zines by seasons. Every season shares one story about Exchange Trip and the extension unit,
Including family, friendship, love, pet and intimacy.

手感 / Texture

裝幀與包裝方式依各期內容不同
而實驗性嘗試，在書架前，盡情
享受尋寶小樂趣。
封面材質統一為觸感極好的羊毛
紙，溫暖你的手指。

Binding and packaging would
be different for experimental
attempts. You can enjoy
searching in front of bookcases.
Covers are all woolen papers
that will warm your fingers.

● 視覺設計 Visual Design　　● 設計作品 Design Works

春號刊 / Spring

寵物，不只是親人或夥伴，衍生全新的情感領域，相互依賴。
藏寶箱的概念，珍藏屬於你們的回憶，永續流傳。

Pets are not just a family member or partner; they have spawned a new field of emotional interdependence.
Treasure chest as the concept, the packaging preserves all the memories you cherish.

夏號刊 / Summer

想念鄉下外婆拿手的醃醬瓜，和遠比眼前所見更清晰的過往。
一線貫穿裝幀，像薄弱卻貫穿情感。
然後，真空袋新鮮包裝。

Missing the pickles made by grandmother and those clear memories in childhood.
One thread across the zine makes sure every page connects with each other. Vacuum packaging keeps it fresh.

秋號刊 / Autumn

說友情。在旅行的過程中，尋找到自我存在的意義。
紙盒像車廂，兩個不同的人一起在旅程中互相扶持。

About friendship, in the process of traveling, they look for the meaning of existence. Different materials from the box symbolize two different souls gather together in the journey, mutual support, and finding the dawn of life.

冬號刊 / Winter

微電影－淺冬眠影音特集。講失戀，與附帶那些隨處可見的思念。衛生紙盒造型與抽取方式。隨意抽取，任意丟棄。

The film - Slow Sleep video feature. Talking about romance, and comes with those ubiquitous thoughts. Tissue carton shape and extraction as idea, it is everywhere but belongs to no one.

EXCHANGE TRIP

帆布袋鏤空，後面有漂亮風景。
一次四本季刊，輕鬆帶走。

Hollow out the canvas bag.
There is simple scenery inside.
For packing all zines.

我們 / Business Card

每張名片都經手工車縫，有隱藏版風景，
也是美美的。

Each card is handmade, with hidden
version of the scenery, and elegance.

兩用 / Card

季刊與機票的組合。撕下資訊，和朋友分享。

Combined with the zine and plane ticket. You can tear the information
off and share with your friends.

瞧瞧 / Website

有網站，一切相關資料都找得到。距離不是問題。
We have a website. Distance is not a problem.

蓋蓋 / Seal

留下足跡，蓋上回憶，祝您旅途愉快。
Leave the footprints and preserve your own memory.
Bon voyage.

設計作品 Design Works　●　　視覺設計 Visual Design　●

王興喬 / Xing-Qiao Wang

flickr.com/photos/show790111
joe790111@hotmail.com

陳奕仲 / Yi-Chung Chen

flickr.com/photos/joychen41
joychen41@hotmail.com

李曉菁 / Xiao-cyanine Lee

flickr.com/photos/46224467@N05a
227004238@hotmail.com

尤敏芳 / Min-Fang Yu

flickr.com/photos/phoebe0924
phoebe0924@hotmail.com

以東方神秘為主題，經由中國歷史或吉祥圖騰，
對中華文化的精神有不同的解讀。

The theme of our brand surrounds the exotic Eastern mystery.
Using Chinese history and ancient totems,
we convey different interpretations of the Chinese spirit.

● 視覺設計 Visual Design ● 團隊 Team

視覺設計
/ DYE渲－自創潮流品牌

Q：專題介紹

A：本品牌以東方神秘風味的主題進行創作，經由一些中國的歷史故事或是吉祥圖騰，使大家對中華文化的精神與精髓有不同的解讀。

Q：製作此作品用的軟體是什麼，它如何將你們的設計發揮到極致？

A：最初以手繪圖像為主，加上Adobe Photoshop CS5和Adobe Illustrator CS5在圖案上面做各種色彩與材質合成的變化，使同一種圖像能有多樣式的發揮。

Q：請談談你們如何克服創作上遇到的瓶頸，也給對設計有興趣的讀者們一些建議？

A：將四人創作的四種不同風格統整出一貫性是一種挑戰，還有思考如何將傳統的東方元素賦予新的表現與視覺趣味。設計就在生活中，從最「貼切」地方下手就對了。想進入這行的新鮮人除了要有自己獨特的想法之外，還要多多接觸其他的事物，設計才會有廣度與內涵。

Q：在設計中，觀者的感受與自我之間，你們認為哪方面比較重要？

A：若自我的重要性大於觀者的感受，比較適合稱純藝術創作。而觀者的感受重於自我的重要性，又顯得過於匠氣沒有深入的內涵，所以兩者並重才是好的設計。

Visual Design
/ DYE

Q：Project introduction.

A：This brand aims for the mysterious nature of the East. People are able to interpret the Chinese culture and spirit with a diversity of views.

Q：Which software did you use in this project? How did it help you bring out the best of your design?

A：Images were drawn by hand at first, then Adobe Photoshop CS5 and Adobe Illustrator CS5 were used to add textures and colors to the images and create the unique looks.

Q：Please tell us how you overcame the difficulties during the project and give some suggestions to the readers who are interested in design.

A：It was a challenge to integrate opinions from four different people and to think of a way to give the traditional Chinese culture a new life. There are infinite amount of creativity in our lives. We just need to incorporate our lives into our designs. People who want to enter the world of design should not fear to integrate their daily ideas into their projects and should communicate with the world in various ways. Everyone's idea is equally valuable. Therefore we should feel free to throw out as many ideas as possible so that great ideas are not neglected.

Q：When it comes to design, does the viewers' perception play a more important role than designer's perception? Or is it the other way around?

A：If designer's ego prevails, the creation is better called as an absolute piece of artwork. On the other hand, focusing too much on the viewers' perceptions might make the creation look too mundane. Therefore, it is the best for us to balance between both elements.

概念發展
/ Development of Ideas

「渲」在五行屬水，也有吉祥之意，表示通過多次的醞釀來烘托出精華。而品牌將渲染之意象與玉璽「刻印」之形象結合，象徵中華文化圖像歷久不衰的精髓。

"Dye" belongs to Water in the Five Elements, also has the meaning of auspiciousness. It represents the essence after several brewing. The brand combines the image with the "engraved" jade, symbolizing that Chinese culture will last forever.

優勢 / Strengths	劣勢 / Weaknesses
1. 手繪風格為主的圖案較獨特較不容易被取代。 2. 對於學生族群，可以做更進一步的了解。 3. 風格較多變，畫風新穎。 4. 與多數潮流品牌的街頭走向不同，主題較具文化內涵。	1. 無直營店面，消費者無法直接接觸商品。 2. 沒有明星代言品牌，曝光率較低。 3. 創作者與市場無沒有直接接觸，對於市場敏銳度可能較低。
機會 / Opportunities	威脅 / Threats
1. 剛好藉著出國展出的機會，增加曝光的機會。 2. 以網站做為通路，通路較活。 3. 美國以此為主題的商品數量較少，應該會成為一個發展空間頗大的藍海市場。	1. 市面上潮流品牌眾多，競爭強烈。 2. 組員畢業後延續此品牌發展較困難。

製作過程
/ Production Process

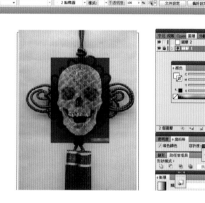

開啟Illustator，新增一個A4檔案，檔案→置入，將選取的兩張圖片，置入於檔案中，確定置入後，點選上方的「嵌入」鍵。

Column → File → open Illustator → File → add an new A4-sized file, click the tool placement on the top. Select the two pictures placed in the file to determine the placement. Click the "embed" button on the top.

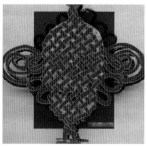

調整透明度，方便兩張圖片重疊作業，大小位置確定後，鎖定第一圖層，保持兩張圖片不會移動。

Adjust transparency. Facilitate the two pictures overlapping operations. Lock the size of the location of the first layer, keep the two pictures still.

新增新圖層，以鋼筆工具描繪骷髏中國結的外型，並套入顏色。並將嵌入的圖片刪除。

Add a new layer with the pen tool to depict the appearance of skull knot, and put in color. Delete the embedded picture.

至於眼窩牙齒部分，必須另外存取在另一個檔案，因為眼窩跟牙齒屬於不同的材質，嵌入先前的兩張圖片在新開的檔案，用鋼筆工具繪製眼窩跟牙齒。

Draw the shape of the full Ministry. The the orbital tooth section must be another access in another file, because the orbital belongs to different materials with teeth embedded in the previous two pictures in the new file. Utilize the pen tool to draw the eye sockets and teeth.

接下來，要增加質感方面，開啟Photoshop，檔案→新增，置入材質圖，再置入之前製作的Illustrator檔案 (骷髏中國結)，記得點陣化置入的文件轉換成圖片，才能做合成動作。設定圖層的混合模式，點選要混合的圖層，選擇想要的合成效果，置入的骷髏中國結，套用色彩增值效果。

Next, to increase the texture, open the Photoshop toolbar at the top → File → new implanted material diagram. And then place before the production Illustrator files. Remember to convert the dot placement file to picture format so as to make synthetic layers to be mixed. Select the desired synthesis effects. Place in the skull knot. Apply the "Multiply" effect.

眼窩牙齒部分，新增圖層置入眼窩牙齒向量檔，點陣化置入圖層為圖片，調整適當大小。

Add a new layer to the orbital part of the teeth, then place in the orbital tooth vector file. Remember to place in the raster image layers as the picture, and adjust it to the appropriate size.

使用魔術棒工具，點選中國結以外的空白處，按住shift→點選要去背的區塊，一次去背完成，刪去材質圖層，背景才會呈現空白。點選眼窩牙齒圖層，魔術棒工具→shift，選取要清除的區塊→delete，骷髏中國結大致完成。

Use Magic Wand tool to click on blank spaces outside the Chinese knot, hold down the shift → click on the backgrounds to be removed, remove them at once. The background would show blank if the deleted part is the material layer.

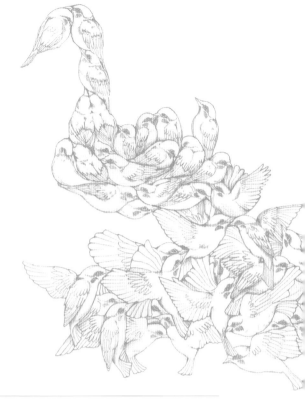

● C 15 / M 100 / Y 90 / K 10

● C 20 / K 100

標誌與標準色 / Logo and Color Plan

品牌將渲染之意象與玉璽「刻印」之形象結合，象徵中華文化圖像歷久不衰的精髓，而紅色也代表中華的吉祥顏色。

The brand combines the dye image with the "engraved" image of jade, a symbol of ever-lasting Chinese culture. In addition, red represents auspiciousness in Chinese society.

產品 / Products

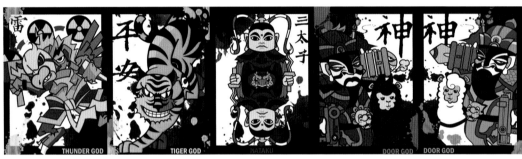

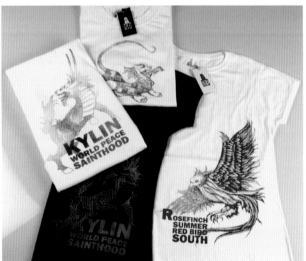

主題系列 / Thematic Series

主題系列可分為神獸、中國圖飾、神話、KUSO。

The series contain Celestial Animals, totems, Mythology and KUSO.

1	2
3	4

1. 中國圖飾　　1. Totems
2. KUSO　　　2. KUSO
3. 神話　　　　3. Mythology
4. 三羊開泰　　4. Shung Young Kie Tie

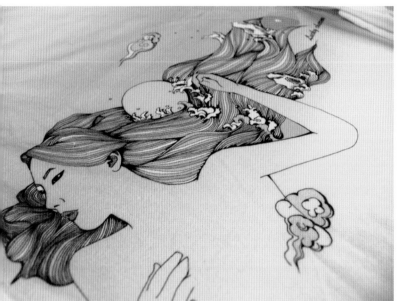

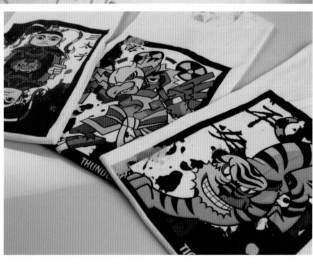

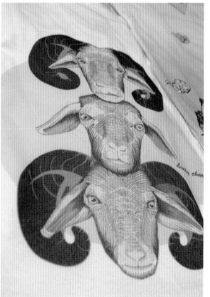

DYE DM設計 / DM Design

型錄內頁的風格以外拍為主，特別配上中國風的背景與古色古香色調的色調，
使品牌形象更為突出。

The style of catalog pages is based on outdoor photoshoot. Moreover,
it is coupled with the Chinese style background and antique color tones to
highlight the brand image.

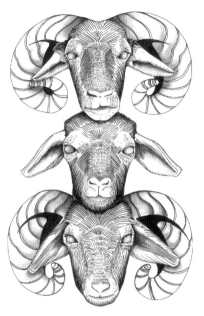

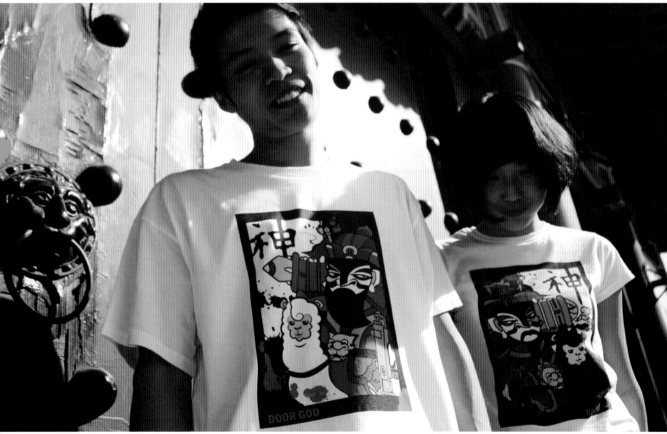

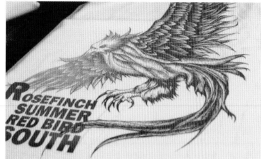

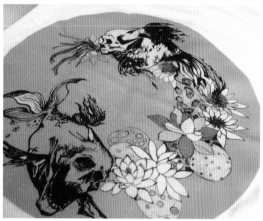

網站設計 / Web Design

網站本身也是型錄的一種形式，而每個圖案也都有典故介紹與不同樣式，使顧客能瀏覽網站中的說明和商品模擬做不同款式的選擇。

The website is another form of our catalog. Each pattern has a story to introduce different styles so that customers can browse the site description and goods simulation of different styles.

➡

邱豐雄 / Feng-Hsiung Chiu

flickr.com/photos/toyoh_q
toyoh@me.com

邱昱瑄 / Yu-Hsuan Chiu

flickr.com/photos/a0185008
a0185008@hotmail.com

陳孟慈 / Meng-Tzu Chen

flickr.com/photos/ryuya1734
ryuya1734@hotmail.com

acTOURist

一小部旅行：
短暫的空閒，來一場電影般的旅行。

acTourist:
Take a Drama Tour in a short time.

● 視覺設計 Visual Design ● 團隊 Team

視覺設計
/ 一小部旅行

Q：專題介紹

A：一小部旅行是顛覆傳統的新型態旅遊。短時間的時程設定並導入電影元素；貼心資訊及互動式簡介，不需要準備、說走就走。

Q：製作此作品用的軟體是什麼，它如何將你們的設計發揮到極致？

A：平面類我們運用了Adobe Photoshop CS5做背景相片合成與色調微調，搭配由Adobe Illustrator CS5繪製而成的人物；多媒體類以Hype製作HTML5行動版網頁，而影片部分則是Adobe After Effects CS5製作影片特效，最後以Apple Final Cut Pro X做影片剪輯就能完成作品了。

Q：請談談你們如何克服創作上遇到的瓶頸，也給對設計有興趣的讀者們一些建議？

A：瓶頸往往出現於靈感發想的階段。而遇到瓶頸時，我們會跳脫出當下的氛圍，並外出走走、看看，放鬆心情。或是到創作景點實際勘景，進而激發創作靈感，同時克服瓶頸所造成的停滯。

Q：覺得團隊合作的優缺點是什麼？如何分工並整合想法？

A：發想階段，能夠經由組員間不同的思考模式與經驗，激發出更多創作靈感；這就是團隊合作有別於個人組別的極大優勢。發揮組員個人專長，使作品更富多樣性。然而，團隊合作相對也有需要克服的缺點，例如：作品風格不一與討論時間較難相互配合等，都需要組員們充分的溝通並彼此調整。

Visual Design
/ acTourist

Q：Project introduction.

A：acTourist is a new type of short time tour. With useful trip information and interactive clips, you will have a delightful moment whenever you'd like to set off.

Q：Which software did you use in this project? How did it help you bring out the best of your design?

A：In graphic editing, we used Adobe Photoshop CS5 to do the color and the photo synthesis. Adobe Illustrator CS5 for creating and drawing characters. In multimedia editing, we used Tumult Hype to build our mobile web pages. As for videos, we used Adobe After Effect CS5 in video effects and Apple Final Cut Pro combined all the movie clips and finished our video works.

Q：Please tell us how you overcame the difficulties during the project and give some suggestions to the readers who are interested in design.

A：Obstacles appear at the beginning of design. We usually get away from the desk to think outside the box. Sometimes we go to the spot where our project is located to inspire ideas and overcome the problems.

Q：What are your opinions about teamwork?

A：We brainstormed different kinds of methods and ideas in our project. That's the advantage between teamwork and individual. Our individual expertise makes up diverse works. However, there are also some problems to overcome. For examples, the different design styles of works and deciding the meeting schedule, etc. Those are needed to be discussed and communicated to improve the efficiency of teamwork.

概念發展
/ Development of Ideas

跳脫既有旅遊型態,以創新二到三小時的短時間旅遊,
結合在地化高雄的電影元素,發展出全新的「一小部旅遊」。

Different from traditional traveling, we create the short time tour
with Kaohsiung movie elements and develop "acTourist."

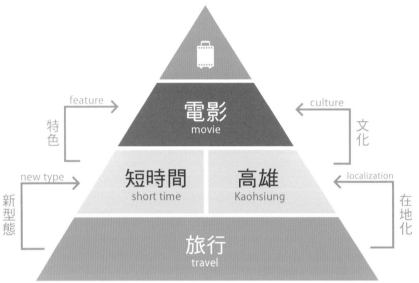

feature / 特色
culture / 文化
new type / 新型態
localization / 在地化

電影 movie
短時間 short time
高雄 Kaohsiung
旅行 travel

特點
/ Features

全新概念,短時間的時程設定,有別於一般的一日
遊、半日遊。

Different from the ordinary day tour, a short
period of time-setting is the new concept.

導入電影元素的劇情式導覽與互動式簡
介,讓旅程更生動活潑。

Interactive clips for you to have a
delightful moment.

提供旅途中的必備資訊,不需要事前規劃行程,能
夠說走就走。

With useful trip information, you can set off
without any preparation.

人物修改
/ Modification of Character

為符合整體概念，一小部（主角）的角色設定為活潑開朗並勇於冒險。經過討論並反覆修改，最終版本的一小部是最富有特色並符合理想中的形象。

To fit with the concept, the character(Yi-xiao-bu) is cheerful and adventurous. After discussion and modification, the final version has the best features of the ideal image.

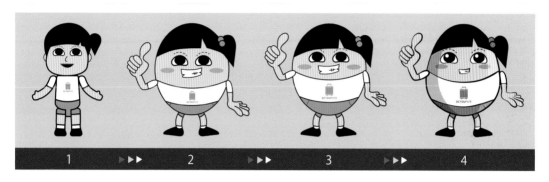

起初，重點擺放在五官，四肢採用常見的公版；第二階段為增加獨特性，將人物整體修整為蛋形；第三階段調整臉部及身體比例。最後，將五官比例調整至完美，並使整體造型上尖下圓，增強了人物的穩定性。

At first, we focused on the facial features of the character. To increase the figure uniqueness, we designed it into egg-shaped. Eventually, we adjusted it proportionately to perfection.

商品應用
/ Product Design

主商品：隨著景點不同，導覽故事的劇情也會有所不同。針對各部劇情，主角一小部會有相對應的變裝。

Main Product (Guide Book): The stories of our products will be different with different attractions. And Yi-xiao-bu will be dressed differently according to the stories.

一次性商品：以一小部作為包裝造型的規劃，增強消費者對主角一小部的印象。

Mechandise (Disposable Products): We use Yi-xiao-bu to design the packaging of products, and enhance the impression.

● C 70 / M 5 / Y 10

藍色以因應主題旅遊悠閒自在且輕鬆無負擔的感覺。

Light blue shows the relaxing feeling of our new travel type.

標誌 / Logo

將旅行箱與電影膠卷做結合。

We combine suitcase and film to create the logo.
Mix the words actor and tourist into "actor" and "tourist" to
be the title.

商品 / Products

富有電影元素旅遊導覽立體書；提供資訊外，並加入互動的樂趣，使旅遊更具
挑戰與趣味。依照各景點活躍時間，如同電影一般分為早、中、晚與夜場。

Pop-up guide books with movie elements. With useful trip information
and interactive clips, adding more fun to the tours. There is a timetable for
the attractions as the way that movie theatre works.

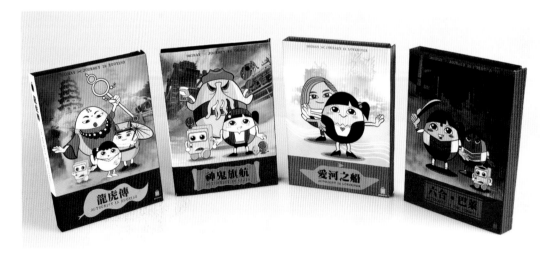

各景點實拍場景照片作為導覽書底圖，並依照故事情節設計不同互動模式與內容。

The guide book is made by photos of attractions. Design different interactive contents by stories of the guide books.

遊客可依故事劇情、路線設定，完成旅程。

Tourists take the journey by following the plot and route of the stories.

一次性商品為臨時性出遊提供簡易、即時的滿足。包裝壓平可作為明信片；減少負擔、富紀念價值。

We offer the disposable goods for temporary tour. The packaging of disposable goods is also a postcard.

人物 / Characters

角色人物的大集合。
All the characters in the stories.

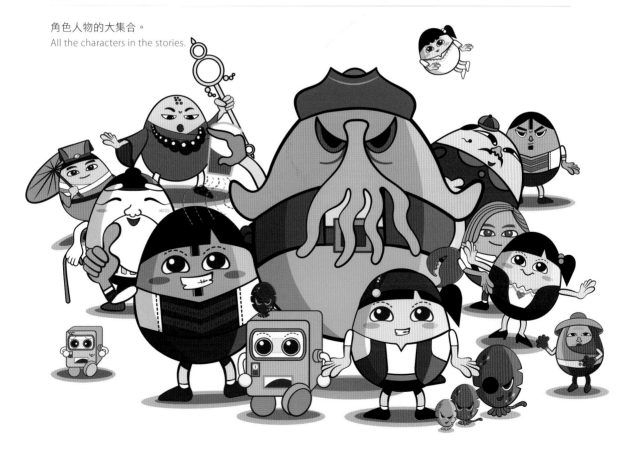

光碟 / Music Videos

隨書附贈MV光碟。內容是以一小部為主角至各景點遊玩
影像。主要提供遊客結束旅程，返家後撥放觀賞以增加
旅程回味性。

There is a DVD inside the guide book. The content
of the DVD is that Yi-xiao-bu goes to the attractions.
Tourists may play the DVD after going home to recall
the memories of the journey.

六合夜市 / Liuhe Night Market

六合夜市(六合巴萊)景點回顧。先由遊客必經
的捷運美麗島站，觀賞光之穹頂、3D藝術作
品；緊接著來到六合夜市，跟著一小部一起重
溫這趟美食之旅。

Retrospect of Liu-he night market. At
first, you see The Dome of Light and 3D
pavement art. And then, walk to Liu-he
night market and review the gourmet with
Yi-xiao-bu.

高雄捷運 - 美麗島站
Metro - Formosa Boulevard Station

旗津 / Cijin

旗津(神鬼旗航)景點回顧。隨著一小部遊玩路
線拍攝，由鼓山渡輪站搭乘渡輪到達旗津，走
過天后宮、爬上旗後砲台與旗後燈塔 等 。

Retrospect of Cijin. Follow the steps of Yi-
xiao-bu, take the ferry from Gushan Pier to
Cijin. Walk through the Ma-zu Temple and
climb the Cihou Lighthouse.

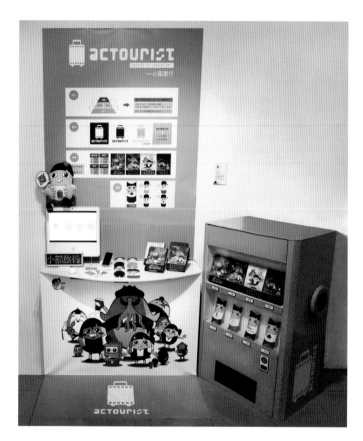

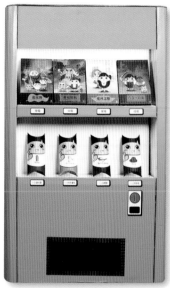

販售型式 / Vending

以自動販賣機作為販售通路,除增加便利性之外,更能帶來話題性。

Use vending machines as the sale approach. Increase convenience and the gimmick.

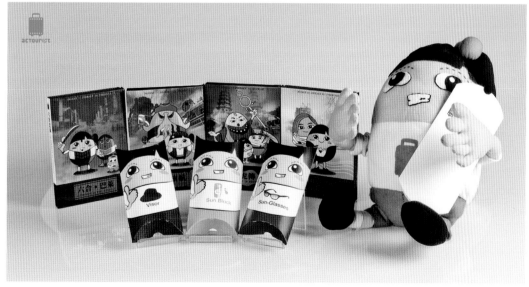

楊雅婷 / Ya-Ting Yang

flickr.com/photos/sating_young
satingrb@hotmail.com

林世豐 / Shi-feng Lin

flickr.com/photos/42959314@N05
jeffs410791@hotmail.com

蔡孟珊 / Meng-Shan Tsai

flickr.com/photos/meng3
poposunday@hotmail.com

一個精彩刺激的遊戲，隨著遊戲的進行玩家
將體驗到設計者的巧思與遊戲的無限驚奇。

Sci-fun is an amazing and exciting game. As the game progresses,
players will experience the ingenuity of the designers and the infinite
surprises of the game, Sci-fun.

● 視覺設計 Visual Design ● 團隊 Team

視覺設計
/ Sci-fun

Q：專題介紹

A：在一間科學實驗興盛的學校裡，玩家將扮演著四位成績優異的小小科學家。
他們是最好的朋友也是彼此間最大的敵人，他們藉由不同的實驗製造出不同的元素來彼此較勁，向學校證明自己是最優秀的。

Q：製作此作品用的軟體是什麼，它如何將你們的設計發揮到極致？

A：使用的是較為普遍的Adobe Photoshop CS5以及Adobe Illustrator CS5等平面繪圖軟體，我們藉由繪圖軟體表現出我們的作品。

Q：請談談你們如何克服創作上遇到的瓶頸，也給對設計有興趣的讀者們一些建議？

A：不斷的思考與討論，並且隨時以圖像式的筆記來記錄想法與刺激產生不同方位的發想。

Q：可以簡述你們的創作歷程與風格轉變嗎？

A：經由多次嘗試之後所表現出來的成果，發現瓶頸與衝突頗多，與最初理想出入甚多，在極短的時間內我們不斷的積極討論，經過多次商討與磨合之後，終於從中發展出團隊夥伴都滿意的作品。

Q：平時如何培養美感，發掘靈感？

A：靈感來自生活週遭，仔細觀察生活中的小細節，往往都能有意想不到的發現及驚奇，藉由適當的運用即能轉換為創作的泉源。

Visual Design
/ Sci-fun

Q：Project introduction.

A：In a school where science experiments prevail, the players will impersonate four outstanding young scientists.
They are best friends as well as greatest enemies to one another. To prove they are the most brilliant, they compete with one another by creating different elements in various experiments.

Q：Which software did you use in this project? How did it help you bring out the best of your design?

A：We used the common graphic design software such as Adobe Photoshop CS5 and Adobe Illustrator CS5 to present our project.

Q：Please tell us how you overcame the difficulties during the project and give some suggestions to the readers who are interested in design.

A：We would discuss and think constantly. Also took image-style notes in order to track down the ideas and stimulate different inspiration.

Q：Could you describe the creating process and the change of style?

A：After several attempts, we found the results were different from the original ideals, and there were many bottlenecks and conflicts. Within a relatively short time, we held many discussions, and reached a satisfying result in our work through negotiation and coordination with team members.

Q：How to cultivate the sense of beauty and explore the inspiration in daily life?

A：Inspiration comes from the daily life. Careful observation to the details could often bring unexpected discovery and surprises. Through proper methods, the inspiration could be converted into the source of creation.

向量繪圖軟體製圖過程
/ Vector Drawing Process

首先繪製草圖，並將其置入Illustrator，新增一個圖層，接著用內建的鋼筆工具描繪基本造型黑白線稿。

First, sketch on the paper, and put the sketch into Illustrator . Add a new layer, then use the pen tool to depict the basic shape with black and white lines.

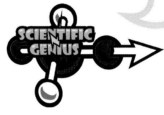

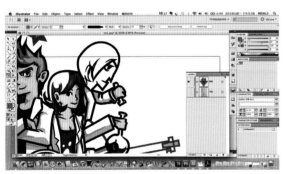

繪製完所有線框之後，先使用即時填色工具將主體的顏色確定，再使用鉛筆工具靈活繪製出陰影的形狀並填入適當的顏色，要注意色塊的前後順序，依序完成後將線稿置於最上層。之後選取所有物件並建立外框，大功告成後存檔便可作各式運用。

After completing all the lines, use instant color tool to determine the main color. And then draw the shadow by using the pencil tool and fill in the appropriate colors. Be aware of the color order. Finish all the shapes, and place the lines to front layer. Select all the objects and create outlines. Finally, save the file for all kinds of use.

雷射切割機作業流程
/ Lasercut Machine Process

打開雷切機開關將USB連接到電腦,接著打開Laser Cut軟體,置入欲切割的檔案。依不同材質設定適合的速度、功率、轉角功率。

Use USB to connect the laser cutting machine to the computer. Then open LaserCut software and the file you wish to operate. Set the speed, power, and corner power according to different materials.

設定完成後按一下右方的DownLoad按鍵,接著檔案便會被載入到雷切機。按一下RunBox按鍵,雷切機即會走檔案的外框,將欲切割的素材移至框內。再三確認後即可將雷切機的蓋子蓋上,按Start按鍵開始進行切割。雷切機會發出提示聲表示切割完成,打開上蓋取出成品即可。

Click the Download button, then the file will be loaded into the machine. Click RunBox button, the machine will make outline of the file. Put the material that you want to cut into the machine. Reconfirm the material is put in the frame. Shut the machine's top, and click the Start button to start cutting. When the machine sends alert, signaling the cutting is completed. Open the top to remove the finished product.

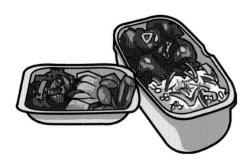

標誌 / Logo

以帶有科技感的字來展現科學實驗的有趣，以及可替換顏色的外圓來增添趣味性。

Use the technical-sensed words to show the interesting science experiments. Replace the color to increase the enjoyment.

主視覺 / Main Visual Design

樣貌和個性不同的四個角色及瘋狂科學家使玩家更容易進入遊戲，並以科學實驗中會用到的儀器組為背景，更採用大膽飽和的顏色使遊戲更具生命力。

The four characters with different personalities and the mad scientist enable players to get a hold of the game easily. Experimental apparatus as the background, the use of bold and saturated colors endows the game with more vitality.

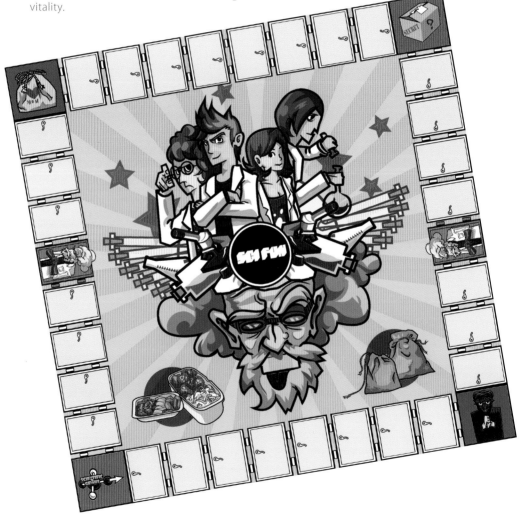

商品 / Products

產品包含了遊戲盒本身以及遊戲包裝、
角色棋子、鑰匙、卡片、說明書、名
片、酷卡……等。

The products contain the game box,
package, chess, keys, cards, instruction,
business cards... and so on.

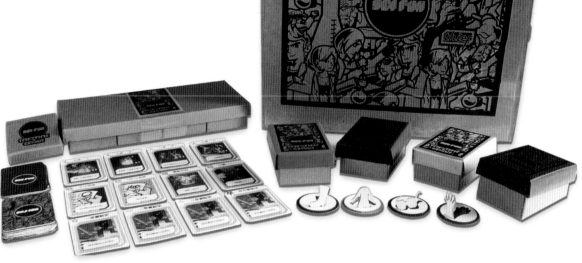

遊戲盒 / Box

遊戲盒採用折疊的收納方式，不只方便攜帶也能隨地打
開並開始遊戲。

The game box can be folded to preserve. It is not
only easy to carry but also convenient to start the
game anywhere.

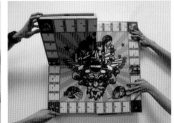
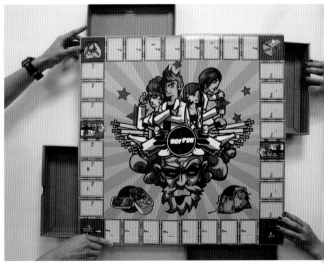

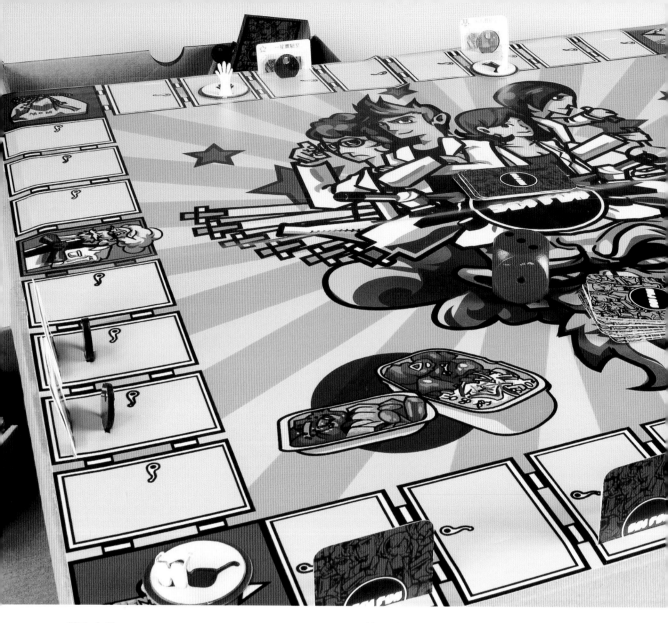

棋子 / Chess

玩家的代表棋子是由科學家身上的護目鏡、手套、實驗衣、靴子作為代表。採用立體造型,更增添遊戲趣味。

The four pieces are designed according to the gadgets of scientists, such as goggles, gloves, lab coats, and boots. The three-dimensional shapes add pleasure to the game.

抽屜 / Drawers

選擇與棋子一樣顏色的抽屜,即可收納屬於自己的鑰匙、元素、以及卡片。

Select the drawer of the same color as chess piece, you can preserve your own keys, elements, and the cards during the game.

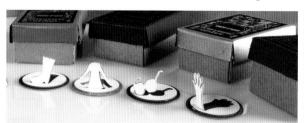

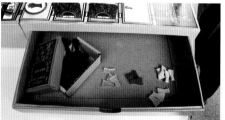

● 視覺設計 Visual Design　　● 設計作品 Design Works

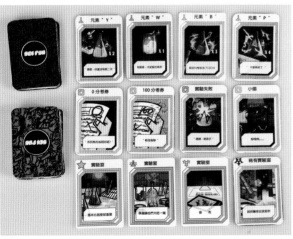

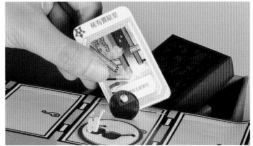

插槽 / Slots

當有足夠的元素即可興建實驗室，把自己要興建的
實驗室插入門上插槽，此實驗室即屬自己。

When there are enough elements to build a
laboratory, insert the card into the slot. Then the
laboratory will belong to you.

鑰匙 / Keys

鑰匙和棋子一樣分為四色，選擇和棋子一樣顏色的
鑰匙，當有足夠的元素興建實驗室時，就可將自己
的鑰匙插入實驗室的鑰匙洞中，實驗室即屬自己。

Keys and the chess pieces are divided into four
colors. Select the key of the same color as the
piece. When there are enough elements to build
a laboratory, you can insert the key into the
key slot on the laboratory door. It means the
laboratory belongs to you.

卡片 / Cards

卡片和主視覺一樣採用活潑風格，在遊戲進行中也
保有樂趣。

Cards and main visual design use the same lively
style to maintain the enjoyment during the game.

➡

江芮瑾 / Peng-Jin Chiang

flickr.com/photos/oasis0702
a19907972@gmail.com

王慈婉 / Cih-Wan Wang

flickr.com/photos/mouseyai
mouseyai@gmail.com

李欣穎 / Shin-Ying Lee

flickr.com/photos/avril3300
irislee0114@gmail.com

SingJe

一本獻給你美好獨身時刻的刊物。
一個人，也可以很好。

A book for you especially when you're alone.
You are good, even if it's alone.

● 視覺設計 Visual Design ● 團隊 Team

視覺設計
/ Single zine

Q：專題介紹
A：每個人都曾經因為「一個人」，感覺孤單寂寞而不知所措。我們提供一本專門給「單人狀態」的人閱讀的刊物，企圖傳達：「一個人也可以很好！」。

Q：製作此作品用的軟體是什麼，它如何將你們的設計發揮到極致？
A：我們著重平面編輯設計類，使用Adobe系列的軟體有Adobe Photoshop CS5進行圖片編修，再以Adobe Illustrator CS5排版，以達成視覺上的美感與協調性。

Q：請談談你們如何克服創作上遇到的瓶頸，也給對設計有興趣的讀者們一些建議？
A：多涉獵不同領域的書籍，多聽多看多想，對生活充滿熱情。若真的文思枯竭不妨好好睡個覺，有時候腦袋放空，或許下一步會有更多創新的好點子！

Q：請舉例最喜歡的雜誌或書籍編排，介紹一下吧？
A：+81月刊排版新穎有靈活度；COCCA可口雜誌可以參考攝影的色調和整體的氛圍；大誌(THE BIG ISSUE)風格清新有文青氣息。可以參考【from Magazines世界創意雜誌嚴選─蜂賀亨 著】這本書裡面有介紹各個國家知名的設計雜誌。

Visual Design
/ Single zine

Q：Project introduction.
A：Due to the feeling of solitude, everyone must have experienced being at lost.
We offer a zine for those who fit to the so-called "Single"status, aiming to convey the message to them, "Even being alone is good!"

Q：Which software did you use in this project? How did it help you bring out the best of your design?
A：We used Adobe Photoshop CS5 to edit our work; and Adobe Illustrator CS5 for the layout. They are good tools to achieve the visual beauty and coordination.

Q：Please tell us how you overcame the difficulties during the project and give some suggestions to the readers who are interested in design.
A：Reading books of various fields. Listening, observing, and thinking. Be enthusiastic in daily lives. If you truly feel exhausted during the creating, I suggest you to get some sleep; good rest helps to come up with new ideas!

Q：Please introduce your favorite layout style of magazines or books.
A：+81 magazine is well organized in terms of original creation. COCCA features color use and overall atmosphere. The Big Issue is very refreshing and good for the youth. You can refer to "From Magazines", there is some introduction to world famous magazines.

概念發展
/ Development of Ideas

你是否也常因為「一個人」而感到空虛無聊和寂寞呢?無論有沒有結婚、有沒有交往對象,只要是處於一個人狀態下,都是我們的目標對象。像是:一個人等車的時候、周末一個人在家的時候等等......。
我們列舉出單身的五種不同情境以及建議閱讀時刻。

「從二變成一」:失戀時一個人的時候
「卸下長日的虛偽」:下班放課後,沒有約會的時候
「晾曬小步曲」:周末不知道哪邊適合一個人的時候
「在自己的小宇宙,指揮若定」:一個人在家的時候
「與你在此刻舉杯」:專欄分享和關於單身的Q&A

你所閱讀的是一種風格,一種態度,一個信念。
一個人,也可以很好。

Have you ever felt vacuous, boring and "alone"? Such as the time waiting for the bus alone or the moment being the only person in your home on weekends, etc. If you are alone, either married or dating or not, you are our prime target. We list five different kinds of conditions of being single and the proper reading moment of each condition.

From two to one: The moment when you are alone and no longer in a relationship.
Disburden the long-term sham: The moment when you have no dating after work.
Minute of saunter: The moment when you have no idea where to go alone at fine weekends.
Conduct your own universe: The moment when you are home alone but don't know what to do.
Toast to yourself at this moment: Here are some columns and Q&A about singleness to share with you.

"What you are reading is a style, an attitude, and a faith."
Even being alone is good!

視覺設計 Visual Design 製作過程 Production Process

網格系統
/ Grid System

構成部分在內部的排列、彼此的相對比例以及其格式位置，於視覺上產生了令人滿意且一致的構圖。訊息內容有層次，透過字型大小、位置，及格式的對齊軸來呈現。

The composition has resulted in satisfied and consistent one on visual under the inner arrangement of combination, mutual ratio and position. There are gradations of message contents which are displayed by the size and position of fonts, as well as alignment of format.

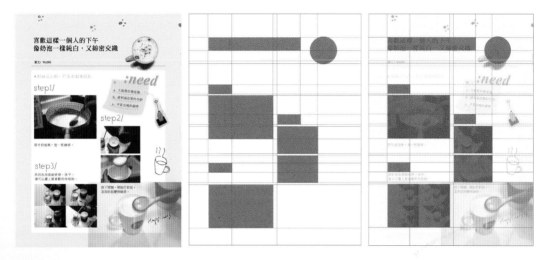

首先確認圖像與文字的構成位置，構成部分為八個灰色長方形及一個小圓形。

First, confirm the position of images and words. The composition contains eight gray rectangles and a small circle.

圓形在所有構圖上，都是變化多端的構成部分。尺寸雖小，卻有龐大的視覺力量，幾乎任何構圖上的圓形都是如此，大小不拘。人的肉眼特別喜歡捕捉圓形。就形狀而言，圓型與長方形部分構成的對比，帶來了視覺上的趣感。

In all compositions, circle is the protean part. Though small, it has enormous visual power. No matter big or small, almost every circle in the composition shares this feature. The human eyes especially like to capture circles. On the part of shape, circle and rectangles form contrast which brings out the visual delight.

圓形與長方形之間的比例，若以直徑為單位，比例約為四分之一，此直徑大致等於最大長方形的寬度。

The ratio of circle and rectangles is four to one with diameter as the unit of measurement. The diameter of circle approximately equals to the width of the largest rectangle.

標準色 / Color Plan

輕盈、優雅的色調表述「一個人」的自在快活。

The light and elegant hues express the freedom and joy of being single.

C 5 / M 55 / Y 45

C 55 / Y 20

標誌 / Logo

纖細、流暢的線條，呈現出「一個人」不受羈絆、保有自我並懂得品味生活的態度。

The slender and smooth lines display the living attitude of being and enjoying yourself with no strings attached while being alone.

SingJe SingJe
星呆文化 星呆文化

宣傳海報 / Posters

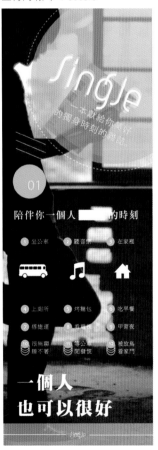

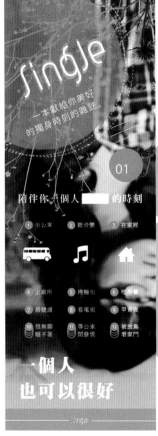

視覺設計 Visual Design　　設計作品 Design Works

單身刊物 / Single zine

Zine的特色是自由、限量、裝訂簡單,有別於出版作業的流程繁複,主張一個人就可以獨立完成,所以我們沿襲了這種精神,創造出獻給你獨身美好時刻的Single zine。外包裝為精美的真空夾鏈袋,內含刊物六本。

The characteristics of Zine are free, limited edition, and simple book binding. Instead of the complex publishing procedures, Zine can be completed independently by a person. Therefore, we follow this kind of spirit, creating and dedicating "Single zine" to you and your lovely single moment. Single zine is packed in exquisite vacuum zipper bag which contains six publications.

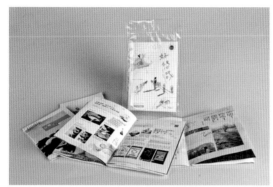
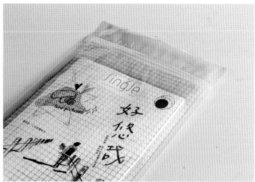

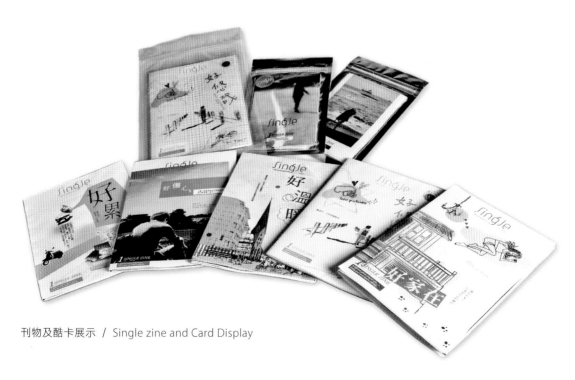

刊物及酷卡展示 / Single zine and Card Display

設計作品 Design Works ● 視覺設計 Visual Design ●

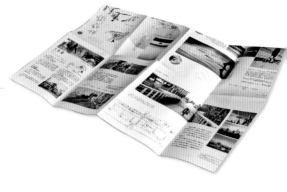

酷卡 / Cards

一套六張，以精美的夾鏈袋為外包裝。

每張皆有不同蘊含的設計，適合每一位獨特的你。

There are six coolcards in a set, packed in an exquisite zipper bag.
Each coolcard has different design with diverse meaning that fits
every unique individual like you.

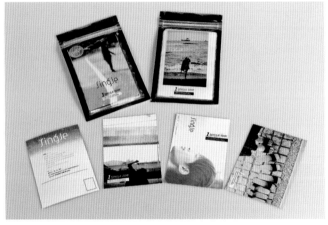

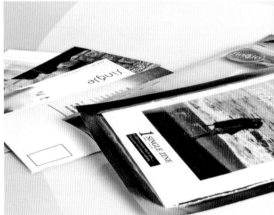

摺頁展示 / Zine Display

展開為A2大小、具質感的紙張，中間裁切一條線，我們稱它為
Zine。是一本適於獨身狀態下閱讀的刊物，背面海報兼具觀賞與收
納的用途。

The so called "Zine", is an A2 size, high quality paper with a
trimmed line in the middle. Zine is a publication which is suitable
for people who are single to read. The poster in the back can be
both admired and stored up.

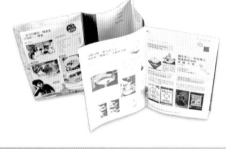

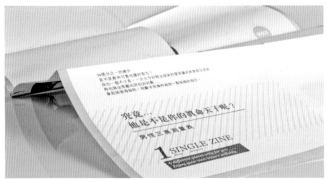

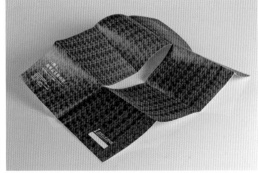

應用 / Application

資料夾使用圓角切割，跟標誌的線條做呼應，
方便一個人看展出遊時收納票根及酷卡等小物。

The file cut round on the side is similar to the
logo. You can keep the coolcards or the tickets of
exhibitions or trips.

1	2		1. 資料夾	1. File
	3	4	2. 資料夾展開	2. File Display
			3. 4. 名片	3. 4. Business Card

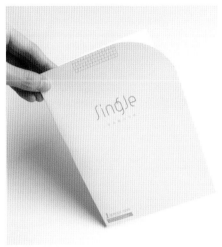

宣傳影片 / Commercial Film

我們試圖以「一支筷子」比喻「一個人」的狀態下能做
的各種事情，以及傳達其中的自在與方便。

We try to use "a chopstick" to imply all kinds of
things that can be done alone as well as how
confident and convenient it is while being single.

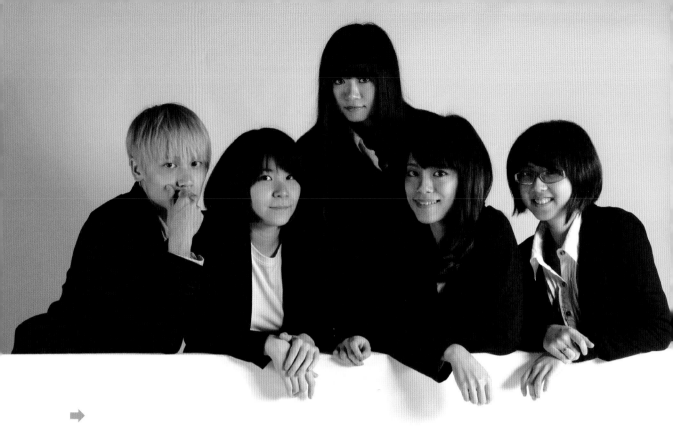

➡

陳威霖 / Wei-Lin Chen

flickr.com/photos/much00011875
much00011@hotmail.com

陳逸芸 / Yi-Yun Chen

flickr.com/photos/yiyunchen
emily8339@yahoo.com.tw

閻柏柔 / Pao-Jou Yen

flickr.com/photos/wawavd101
wawavd101@hotmail.com

紀　薇 / Wei Chi

flickr.com/photos/smileie
smileie@hotmail.com

陳羿希 / Yi-Hsi Chen

flickr.com/photos/jasmine1615
june1615@yahoo.com.tw

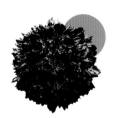

媒介連結雙方，完成了相互溝通的藝術。
不是生命的主角，卻是缺一不可的零件。

Medium has linked between the two sides,
completing the art of mutual communication.
It plays an indispensable part in life even though it is not protagonist.

● 視覺設計 Visual Design　● 團隊 Team

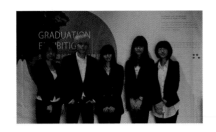

視覺設計
/ 整體形象規劃 Be

Q：專題介紹

A：Be＝媒介＋觸覺＋點字。
我們將Be解釋成媒介，是連結雙方的溝通橋樑。用觸覺來代表溝通的媒介，以點字代表觸覺做視覺構成。物體在不同的環境下會呈現不同的樣貌，我們嘗試著用視覺解釋媒介，點字的黑點加上質感呈現的樣貌，相當於媒介在不同環境下連結本體與外在條件之呈現。透過觸覺而傳達訊息為我們的主要概念，希望藉由視覺與觸覺的連結交替，達到溝通和傳達的目的。

Q：製作此作品用的軟體是什麼，它如何將你們的設計發揮到極致？

A：作品分成平面編輯與多媒體兩大類，主要用Adobe CS Master，再以CINEMA 4D輔助製作。如Adobe Indesign CS5可以整合並大量連結圖片與文字，便於書籍編輯；Adobe Illustrator CS5以向量之利便於排版與繪圖；用Adobe Flash Catalyst CS5編輯動態網頁；Adobe After Effects CS5負責營造情境特效與影片製作；CINEMA 4D模擬立體材質。

Q：請談談你們如何克服創作上遇到的瓶頸，也給對設計有興趣的讀者們一些建議？

A：設計就是為了要解決問題，我們的挑戰就在於勇於面對實際情況，將概念與畫面做結合，讓畫面易於解讀。建議對設計有興趣的讀者可以多累積實際經驗，去解決設計流程會出現的問題。

Q：請舉例最喜歡的雜誌或書籍編排，介紹一下吧？

A：IdN雙月刊介紹近期新穎的設計風格，並有設計師訪談，幫助創作思考與激發靈感。+81季刊編排靈活多變，創意的編輯手法使刊物本身即為一件設計作品。

Visual Design
/ Identity Development Group Be

Q：Project introduction.

A：Interpreted as a medium, Be is the bridge connecting two parties. The tactile sense represents the medium of communication and Braille as the construction of vision. Objects have various appearances in different environments. We try to use visions to explain the medium. Under different environments, the medium connects the internal and external condition and shows various appearances of objects, like the material of black dots of Braille. The main concept is to convey the messages through the tactile sense. To communicate via the connection between vision and the tactile sense.

Q：Which software did you use in this project? How did it help you bring out the best of your design?

A：The software can be categorized into two types: graphic editing and multimedia. We mainly used Adobe CS Master with the assistance of CINEMA 4D. For example, we used Adobe InDesign CS5 for book editing, to integrate and combine pictures and words; Adobe Illustrator CS5 for composing and drafting; Adobe Flash Catalyst CS5 to edit dynamic pages; Adobe After Effect CS5 for film editing and special effects producing; and CINEMA 4D to simulate 3D materials.

Q：Please tell us how you overcame the difficulties during the project and give some suggestions to the readers who are interested in design.

A：We design in order to solve problems. The challenge is to face the circumstances, combine the concept and the picture, and make the picture understandable. We would suggest the readers to increase more practical experiences of design to solve the problems they might encounter during the procedure of design.

Q：Please introduce your favorite layout style of magazines or books.

A：IdN Bimonthly introduces the latest design style and includes designer interviews which inspire more ideas. The creative layout of +81 Quarterly makes the magazine itself a design work.

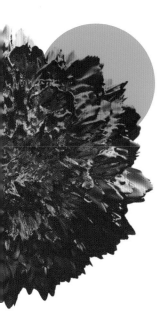

概念發展
/ Development of Ideas

由主題Be開始做延伸,以樹狀圖的形式發展出許多相關意象,
最後決定以媒介為主要核心概念。

Using the medium as a core concept, and "Be" as a starting
point to develop relevant ideas.

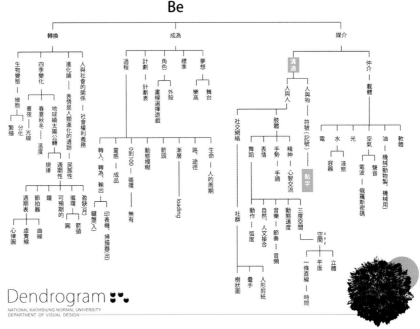

Dendrogram

NATIONAL KAOHSIUNG NORMAL UNIVERSITY
DEPARTMENT OF VISUAL DESIGN

軟體算圖
/ Render

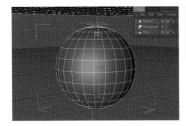

放入一圓球、一平面與背景物件
後,將圓球物件化。

Place a ball, a plane surface, and
background object, then make
the ball object-based.

設定三個材質。分別作為間接光
源、背景與圓球的材質。

Set three different materials
respectively for the indirect light
source, the background, and the
ball.

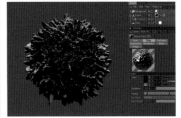

Material Parameters:

1. Color : R.225 G.225 B225

2. Luminance : R.225 G.225 B225

3. Dispalcement-Texture :
 Noise (Displaced Tubulence)

海報修改
/ Modification of Posters

運用美的形式原理的均衡原則,我們在海報構圖裡的中軸兩旁,分別放置形態不同
但質量均等的材質球,讓視覺感受產生平衡的感覺。

Using the balance principle of beauty theory, we put different types of material
balls, same quality, on two sides of the poster to bring out the balance of vision.

一開始選擇不同的材質圓呼應觸覺的概念。以點字形式
來傳達觸覺意象,欲創造出不同以往的視覺風貌。

We choose the various materials to show the
concept of the tactile sense. Use Braille to convey
the image of the tactile sense which is different
from visual images being shown before.

第二次修改時,將構圖簡化,並且減少材質球的變化,
增強視覺張力。為使閱讀性提高,因此在排版上將文字
與圖像資訊做區隔。

We simplify the composition, reduce the changes
of materials, and strengthen the tension of vision.
To make the porter more readable, we separate
the text and images on it.

欲破除原本稍顯擁擠的構圖,將中間的區域改成以打凸
的加工方式,希望可以呈現若有似無的層次感,讓遠看
與近看有不同的感受,提高與觀者的互動及趣味性。

To give different views to the readers, we
protrude the central part to make our work more
interactive and interesting.

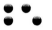

標準色 / Color Plan

將形象定位為乾淨簡約的風格，用標準色來平衡材質球的重量感。
The image is orientated to be clean and concise. Therefore, the color plan could balance the weight of material balls.

C 80 / M 5 / Y 10

C 30 / K 100

標誌 / Logo

將平面與立體做結合，呈現輕與重之間的平衡感，並運用標準色襯托材質球，產生空間感。

We combine plane and three-dimensional objects to show the balance between lightness and heaviness. The color plan sets material balls off and bring extensity out.

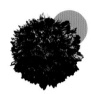

海報 / Poster

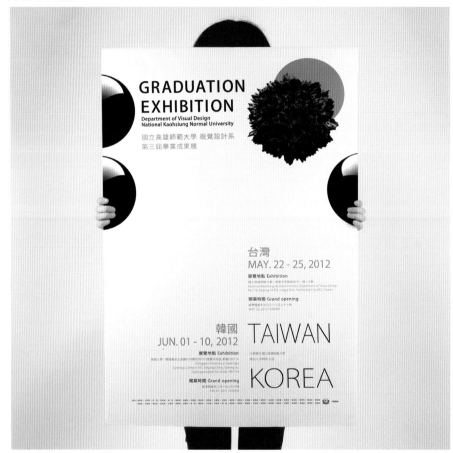

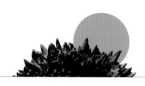

周邊商品 / Merchandise

利用主視覺既有的元素延伸發展成一系列的周邊商品，表現乾淨簡約的風格。

We develop the original elements of main visual design into a series of products to show the simple and concise style.

1	2
3	4

1. 周邊商品　1. Merchandise
2. 個人名牌　2. Nameplate
3. 名片　　　3. Business Card
4. 書籍設計　4. Book Design

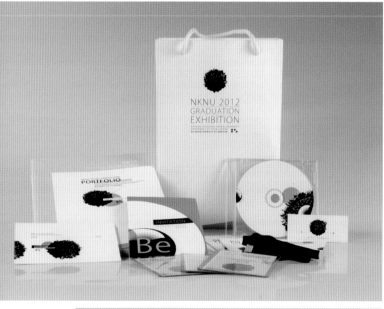

邀請卡 / Invitation Card

利用球形的元素摺疊設計而成的邀請卡，同時為具有功能性的簡介內頁固定夾。內頁匯集各專案的簡介，作為展前的預告。

The invitation card is designed with folded spherical elements which can be clips of introduction pages as well. The pages include introductions of all projects and are the preview of the exhibition.

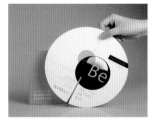
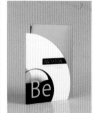

展場設計 / Exhibition Design

延伸主視覺的簡約風格，不過度綴飾，並用白牆襯托材質球。使用壓克力表現材質球的層次，並利用立體點字將觸覺與視覺做結合。

We extend the concise style to the vision without much decoration, and set off material balls by the white wall. Acrylic is used to show the level of material ball. The three dimensional Braille combines the vision and sense of tactile.

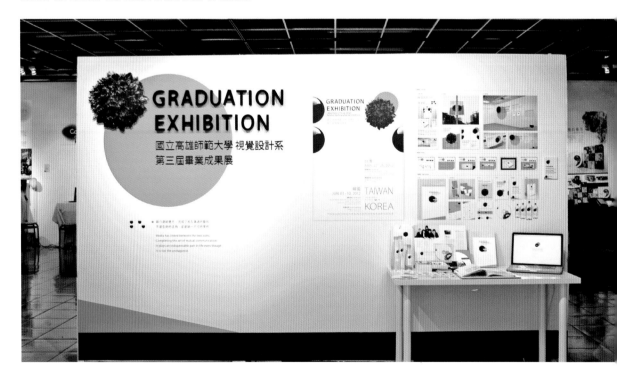

1	2
3	4

1. 打凸效果	1. Embossed
2. 酷卡	2. Card
3. 紙袋	3. Paper Bag
4. 酷卡	4. Card

材質應用 / Material Application

周邊商品運用了打凸的加工方式，欲突顯材質球與點字的觸感。
除了視覺之外，讓觸覺也成為一種溝通的媒介。

We make the products convex to highlight the tactile sense
of the material balls and the Braille. Not only the vision is a
communication medium but the tactile sense as well.

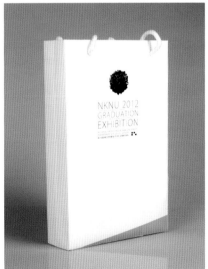

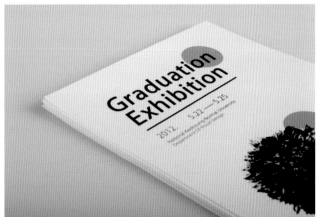

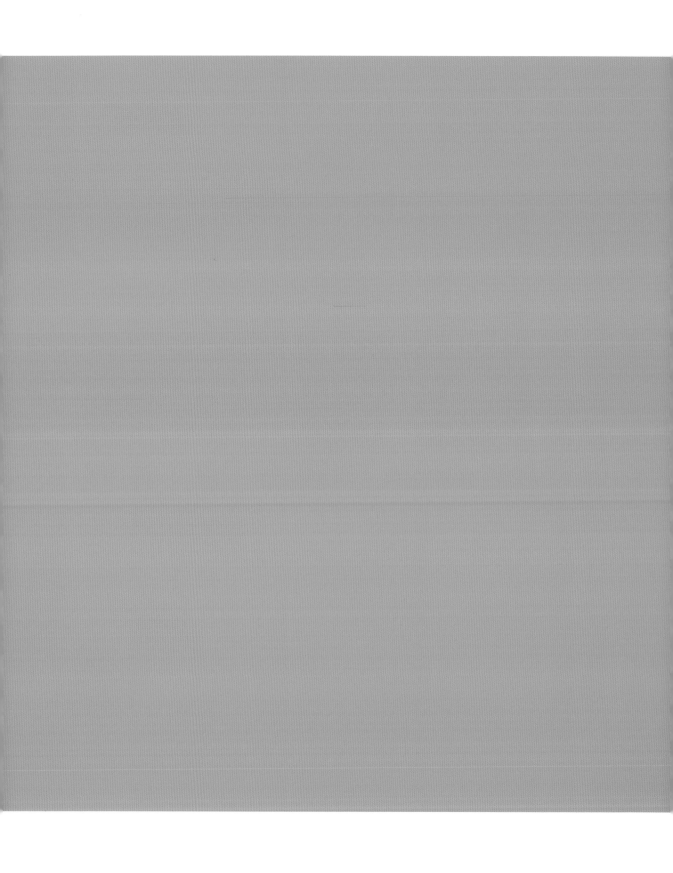

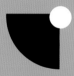

包裝設計
Packaging Design

Class of 2012
Department of Visual Design
National Kaohsiung Normal University

張瓊文 / Chiung-Wen Chang

flickr.com/photos/joankaminari
joankaminari@gmail.com

 以句逗休憩的東方思維。

Pause and rest of the Oriental thinking.

● 包裝設計 Packaging Design ● 個人 Individual

包裝設計
／馥荷藥茶

Q：專題介紹

A：馥荷藥茶

品牌名稱是「馥荷」，命名是取自「複合」的諧音。中藥材大多是將多種不同的中藥混合使用，是一種複方的概念。

「馥」這個字表示香氣，「荷」則是荷花，象徵沉默特性，荷花本身的香氣很淡雅，讓人有放鬆的感覺，也希望使用產品的消費者也能夠得到心靈和身體上的放鬆。

Q：製作此作品用的軟體是什麼，它如何將你的設計發揮到極致？

A：Adobe Illustrator CS5去做包裝版面上的編排和繪製展開圖；而Adobe Photoshop CS5則是做修飾插畫圖稿、照片之用。另外也在Adobe Photoshop CS5中直接上包裝的色彩，善用圖層屬性，能夠將簡單的色彩做出豐富的效果。

Q：請談談你如何克服創作上遇到的瓶頸，也給對設計有興趣的讀者們一些建議？

A：設計過程的前期常碰到不知如何將抽象概念轉化成圖像符號的問題。解決方式是先放下前述討論的過程，以概念主題為中心，開始畫所想到的圖像。累積一定的數量後，就比較容易找到出色的結果。設計需要了解很多事物，平常多閱讀，對於從事、欣賞設計的角度才會更為寬廣、更有層次。

Q：製作包裝時，時常需要考量環保問題，請問你如何在設計與環保間取得平衡？

A：設計與環保間的平衡在於包裝的收藏價值。能不能將包裝做到讓人想保存，即使所使用的材質是不能回收的，但消費者願意收藏，就比較不需要考量回收的問題。

Packaging Design
/ Lotus Aroma

Q：Project introduction.

A：The brand's name is "Lotus Aroma". In Chinese, "Lotus Aroma" sounds similar to the homonym "compound" ("Fu-He"). It's a compound concept derived from the mixture of traditional Chinese medicine.
"FU" means aroma. "HE" means lotus. Lotus symbolizes tranquility. The aroma of lotus is elegant and soothing.

Q：Which software did you use in this project? How did it help you bring out the best of your design?

A：Adobe Illustrator CS5 was used for editing and structure drawing. Adobe Photoshop CS5 was used to modify the illustrations and photos; also I used it to color my packaging design. Be handy with the layer properties can make simple colors bring out the best effects.

Q：Please tell us how you overcame the difficulties during the project and give some suggestions to the readers who are interested in design.

A：In the beginning, I didn't know how to convert abstract concepts into graphic symbol. My solution was to put everything on hold, then drew many icons on the paper as possible. When accumulating a certain amount of icons, I found the best result. Reading extensively could improve the way we engage in design.

Q：How do you make a balance between design and environmental protection?

A：The balance between design and environmental protection is the collective value of the package. If consumers are willing to collect, even the material cannot be recycled, it won't be considered a recycle problem.

概念發展
/ Development of Ideas

以中藥櫃為核心概念發想，包裝設計是單格抽屜的形式，內有長方形的個包裝。將每個單格抽屜疊在一起，就好像中藥房內最令人注目的中藥櫃。

The packaging design is inspired by traditional Chinese medicine cabinet. Each packaging design is a drawer and has many small packages inside. When all drawers stack together, it looks like a traditional Chinese medicine cabinet.

繪圖工具
/ Tools

鉛筆、描圖紙、沾水筆、G筆、漫畫稿紙。

Pencil.Tracing paper.Dip pen.G pen.
Comic manuscript paper.

製作過程
/ Production Process

確定包裝形式後，找尋可用素材，以手繪感線條加上用Photoshop上色，在Illustrator製成展開圖，輸出後製作成立體包裝盒型。

After deciding the form of packaging, find the useful materials. Draw lines by hand and color in Photoshop. Make it able to be printed by Illustrator. Finally cut the paper and turn it into package.

1. 找出使用的素材，轉成灰階形式。在Illustrator鏡射，輸出後以描圖紙描線。
2. 複印到紙張上面，以G筆、沾水筆上墨線。用曲線功能可以將背景雜點減少。
3. 將線稿掃描，在Photoshop調整、去背。

1. Turn materials into grayscale. Trace lines on the tracing paper.
2. Copy the lines to the comic manuscript paper. Use dip pen and G pen to draw ink lines. Use "Curves" to decrease the dots.
3. Scan line draft and remove background in the Photoshop.

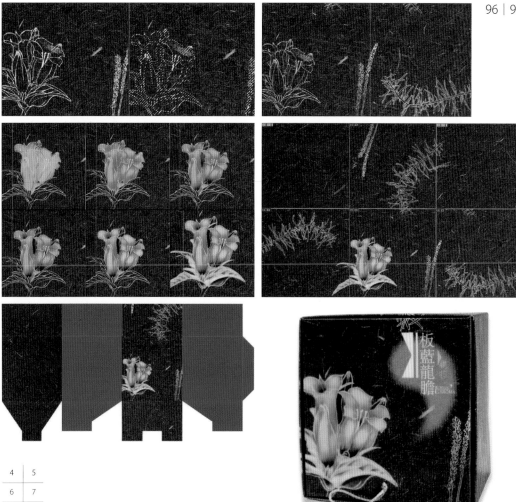

4	5
6	7
8	9

4. 將線稿拉入背景Photoshop。

5. 按著Ctrl點選線稿圖層，使線稿被選取。點選筆刷工具，透明度75%，柔邊狀態，分別上不同的色彩。

6. 將線稿圖層放最上層，開新圖層，對花的圖案分層上色，由淺至深。最深色狀態選「色彩增值」。

7. 拉參考線切割畫面，用切片將畫面切成六區塊，轉存成「儲存網頁與裝置用」。

8. 將圖片置入已經畫好展開圖的Illustrator中排好。將文字、輔助圖形、裁切線放到位置上。

9. 輸出後依裁切線切割後，折好黏貼後完成。

4. Put line draft into background.

5. Press "Ctrl" and click on line draft layer. Choose brushes (transparency 75%) and color on the line draft layer.

6. Put line draft layer on the top and create a new layer. Color the new layer(light to dark). Select " Multiply"on the darkest color.

7. Use slices to cut picture into six pieces. Save the file for web use.

8. Put pictures(jpg) into Illustrator. Place words, auxiliary graphics and crop lines to the right position.

9. Print and cut the paper. Fold it and glue it up, then it is done.

標準色 / Color Plan

採取偏紅的紫色來做為主視覺色彩，帶有藥材溫暖的意像。

Reddish purple as the main visual tone. It has the warm imagery of Chinese herbal medicines.

● C 70 / M 90 / Y 45 / K 10

◐ C 15 / M 20

標誌 / Logo

馥荷的中心理念是以句逗休憩的東方思維，希望給人一種放鬆的感受。在字體設計中以逗點取代「荷」字的一部份，希望以逗點去傳達休息的感受。

"The Oriental thinking of pause and rest" is the concept of Lotus Aroma. Use a comma to replace part of the word "aroma" in typography. Lotus Aroma wants to convey a feeling of relaxation to our consumers.

馥荷

包裝設計 / Packaging

以中藥櫃為核心概念發想，包裝設計是單格抽屜的形式。將每個單格抽屜包裝疊在一起，就像整面的中藥櫃。而每格的中藥圖案都不同，總共有十六種。

The packaging design is inspired by traditional Chinese medicine cabinet. When all drawers stack together, it looks like a traditional Chinese medicine cabinet. There are sixteen different patterns on each package.

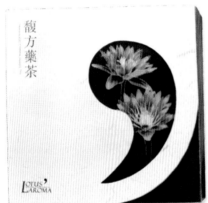

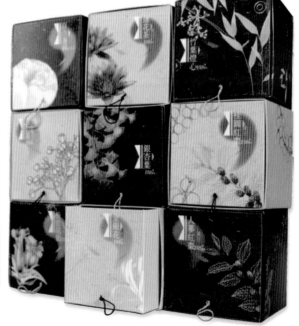

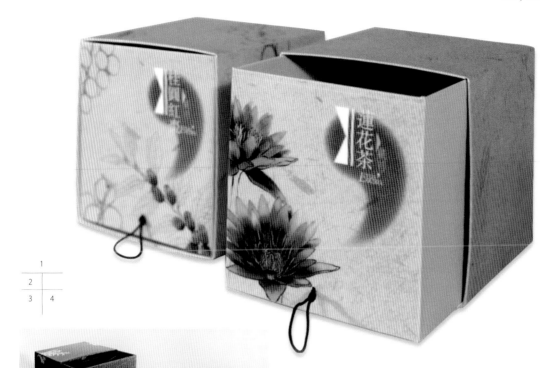

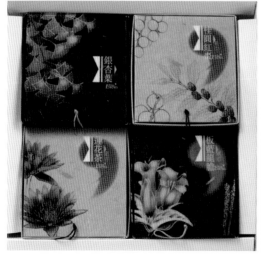

1. 淺色包裝
2. 每個單格抽屜內有數個小包的個包裝中藥茶包
3. 禮盒表面
4. 禮盒內部可以自選四種中藥茶放入

1. Light Packages
2. Each package is a drawer and has many small packages inside.
3. Gift Box
4. Gift box can contain four packages in it.

周邊商品 / Merchandise

使用主視覺既有的元素發展成一系列的商務用品。
Develop merchandise from main visual elements.

會員卡 / Membership Card

杯墊 / Coaster

名片 / Business Card

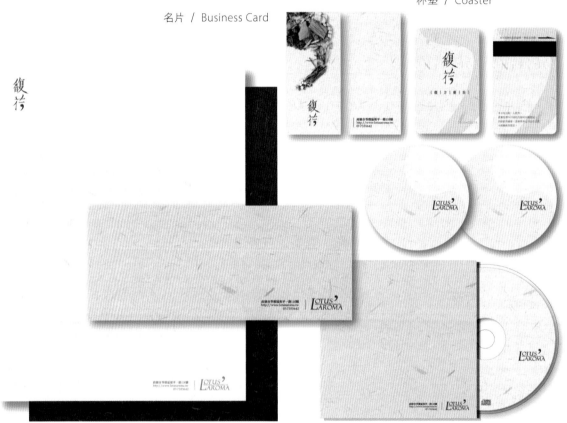

信封信紙組 / Envelopes and Letters

光碟組 / CD

展場手冊 / Exhibition Manual

放在展場中給來往的人所翻閱的手冊。裡面除了對商品的介紹外,也收錄有關的一切資訊(品牌、商品、包裝、藥茶介紹)。

The manual contains product introduction and related information (brand, product, packaging, and herb tea introduction).

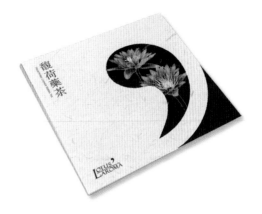

網站設計 / Web Design

更詳細的內容放在網站上面,以供消費者深入了解我們的品牌。網站規劃裡面包含品牌介紹、產品介紹、包裝介紹、商務應用介紹、展覽這五個項目的細部介紹。

There are much more details on the website for consumers to get to know our brand. There are introductions on the brand, products, packaging, merchandise and exhibition.

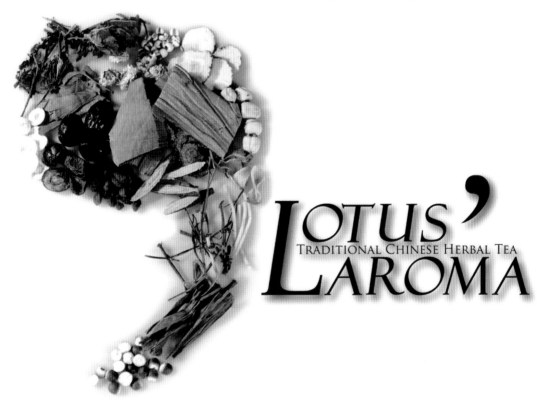

陳南瑾 / Nan-Jin Chen

flickr.com/photos/39115299@N03/
verbena1989@gmail.com

陳淑鈺 / Shu-Yu Chen

flickr.com/photos/oiccio/
verena155@hotmail.com

林雅瑩 / Ya-Ying Lin

flickr.com/photos/miyavi0331/
miyavi0331@hotmail.com

曾經停留掌心的寶石，能再成為你的保護色嗎？

Gem once remained in the palm.
Could it become your protective color again?

● 包裝設計 Packaging Design ● 團隊 Team

包裝設計
/ Precious

Q：專題介紹

A：模擬精品巧克力品牌–Precious，有「令人珍愛」之意。
策略：建立重視環境、有助於社會的企業形象，同時達
到綠色教育與商業目的。
概念：台灣稀有原生昆蟲是生態存亡指標，如珠寶般該
被視為珍貴。主視覺結合兩者意象，以膚色設計口味，
期許人類對環保應努力不懈，直到能解除萬物的防備，
與其親近、共生的一天。

Q：製作此作品用的軟體是什麼，它如何將你們的設計發揮
到極致？

A：包裝、DM、海報平面部份使用Adobe Illustrator
CS5，因為我們風格偏向向量且編排部份也易操作。
修圖上使用Adobe Photoshop CS5，它在修圖方面可
做細部調整，呈現出更好的效果。
建模使用3ds Max。因巧克力造型簡單，它可做簡單的
塊面切割，操作上輕便簡易，方便快速建模並修改。

Q：請談談你們如何克服創作上遇到的瓶頸，也給對設計有
興趣的讀者們一些建議？

A：專題企劃一開始，我們總是在思考「想做什麼」，在
不斷跟老師討論的過程中，發現比起「喜歡做什麼專
題」，我們想傳達的「核心目的」是否有所意義、關乎
眾人生活之事而非己之欲，更為重要。
設計相較於其他職業來說較為靈活，服務對象範圍廣
大，相對的我們平時需要增廣見聞以增加作品深度，並
對美的事物保持熱忱、提升感受，這會是做設計的一大
動力。無論台灣設計界現狀如何，未來有機會去改變的
不正是即將加入的我們？與其去想像設計是一條怎樣的
路，不如對自己的興趣與天分負責，盡力投身其中。

Packaging Design
/ Precious

Q：Project introduction.

A：Create a brand of chocolate boutique – "Precious"
means treasurable. Strategy: Build a brand image
concerning environmental attention and the
benefit of community. To reach both the green
education and commercial purpose. Concept: Rare
aboriginal insects are indicators of ecology, same
as jewelry, and both should be treasured. The visual
image combines them both. We make skin color
chocolate with different kinds of flavors. We hope
that humans could protect the environment so that
one day we could live in peace with all creatures.

Q：Which software did you use in this project? How
did it help you bring out the best of your design?

A：For graphic design, we used Adobe Illustrator CS5
because our style tended to be vectors, and was
easy to operate. For photo modification, we used
Adobe Photoshop CS5 and it worked well.
3ds Max was used in modeling. Because the shape
of chocolate is simple, it is easier to do simple cut
with 3ds Max, and it is easy to operate, model and
modify.

Q：Please tell us how you overcame the difficulties
during the project and give some suggestions to
the readers who are interested in design.

A：During the project planning, we were always
thinking "what do we want to do?". But after the
discussion with the instructor, we found that,
compared to "what we like to do", it is more
important whether the "core objective" we wanted
to express presents the meanings and whether it
gives awareness to public matters.
Design serves wider range of groups, so it is
necessary to expand the horizon to extend the
depth of work. Besides, we should always stay
passionate for beautiful things, which is the main
motivation of design. No matter how the state of
design in Taiwan is, we are the ones that have the
opportunity to make changes. Instead of imagining
what the way of design would be, it's better to be
responsible for our own interest and talent, and try
our best.

概念發展
/ Development of Ideas

「有益設計」→「有助台灣」
→「宣傳保育」→「吸引人們」→「大眾化商品」

「Useful Design」→「Help Taiwan」
→「Publicize」→「Attract」→「Popularize」

步驟：
1. 巧克力與保育昆蟲，皆因人類貪婪，「即將消失」。
2. 昆蟲被稱為活寶石，璀璨珍貴。
3. 比起物質，牠們的生命更值得守護。
4. 以寶石的視覺特色重新設計昆蟲符號，
　　以巧克力商品為載體。

Steps:
1. Chocolate and rare insects are both disappearing.
2. They are called living gems.
3. Their lives are more important than gems.
4. Use edges and corners of the gem,
 and redesign them. Present in chocolate.

標誌發想
/ Logo

以蝴蝶形狀的「手」護，來表示守護的心意。
但有立場錯亂、被捧物不明的問題。
The butterfly-shaped hand means "Protect".
But the object in hand is not clear.

期盼傳遞一顆蝴蝶心：即是對環境的同理心、
美麗的綠色心境。且每一隻都是一顆寶石。
Butterfly heart：Empathy to the Earth.
Every insect is a gem. (Final logo)

Choco	巧克力	●	K 100
Natural	自　然	◔	C 25 / Y 85
Human	人　類	◑	C 5 / M 85 / Y 95

標準字發想
/ Font

我們參考各種飾品、珠寶內的寶石切
割過程來創作。
We refer to gem cutting technique
to create our logo font.

● 包裝設計 Packaging Design　　● 製作過程 Production Process

巧克力模型教學
/ Chocolate Models

真正的巧克力保存不易，為了展出實品，需要製作巧克力模型。

Real chocolate is not easy to preserve. To show the products, making chocolate models is necessary.

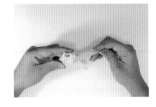

將模型輸出成中空以節省成本，填入補土並待乾，若有裂痕則繼續填入補土。	顏料調色至接近巧克力色並塗滿模型，待乾之後繼續補顏料使其顏色較厚實。	底部補土待乾之後，在各隻昆蟲底部塗上各自代表的標準色，建議多上幾層顏料。	在底部塗上一層保麗龍膠以營造糖衣的透明感，須注意保麗龍膠產生的小氣泡。
Models are rendered into hollow. Fill in putty and wait until they dry. Fill in more putty into the cracks if there is any.	Mix the paint to chocolate color and paint it on models. After they dry off, continue adding paints on to make color richer.	After the putty dries, paint the bottom of each model with its representative color. It is better to add more layers of paints.	Coat with a layer of Styrofoam glue at the bottom to create sense of sugary transparency. Notice small bubbles from Styrofoam glue.

包裝製作
/ Packaging

考慮到包裝的堆疊性、展開置放的便利性，又期望呈現寶石外型的概念在其中，嘗試包裝結構的耐心是必要的。

Consider the convenience of stacking, and also anticipate the concept to show the shape of gems could be included. Therefore, the patience in trying different structures is needed.

 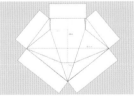

因巧克力為不規則型，因此將巧克力模型擺放在適當的位置並預留隔板位置。	在紙上依照設計圖畫上盒型展開圖，並在圖中預留裱紙及底盒卡紙厚度。	為使盒型立體，將襯底卡紙做破壞性的裁切(a)，切掉的多寡則由突出多少決定。	把所有應連接的邊緊密黏牢後再上裱紙。因為是立體型故設計裱紙時要注意誤差。
Because chocolate is in irregular shape, put it in appropriate place and reserve partition divisions.	Draw the expanded figures on the paper according to the design. Reserve mounting plate and space for thick cardboard.	To make the box solid, do the destructive trim on lined paper (a). As regards the amount of cutting depends on its protruding parts.	Glue all edges tightly and mount on paper. Because it is solid, you need to notice the possible errors when designing mounting plate.

precious

Since 2012 Nov.

Reflect Retain Reproduce

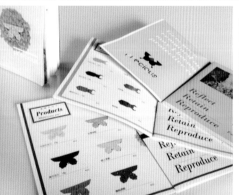

1		
2	3	1. 品牌海報 1. Brand Poster
	4	2. 商品DM 2. Product DM

1. 品牌海報 1. Brand Poster
2. 商品DM 2. Product DM
3. 個人名片 3. Business Card
4. 名片效果 4. Business Card Effect

文宣與海報 / Publication and Poster

用膚色巧克力的巧思提升品牌辨別度，強調獨家的昆蟲造型，並使用適合閱讀的大小及富有手感的紙材吸引閱讀者。假設「若牠們就活在我們之中，會是怎樣的人？」，用感性手法傳遞保育類昆蟲的知識，進而讓人產生同理心。

Chocolate with skin color on it to elevate the brand identity, and to emphasize the insect models. Use well full feel paper and appropriate size to attract readers. "What if it is one of us? " as the concept to arouse people's sympathy.

● 包裝設計 Packaging Design ● 設計作品 Design Works

名片 / Business Card

將摺紙的趣味融入其中，在規格正確的前提下，創造立體感。
Integrate the Origami into the business card, with appropriate size.

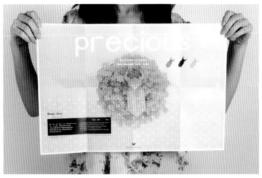
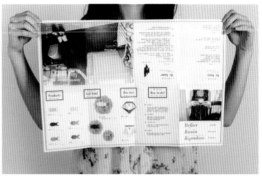

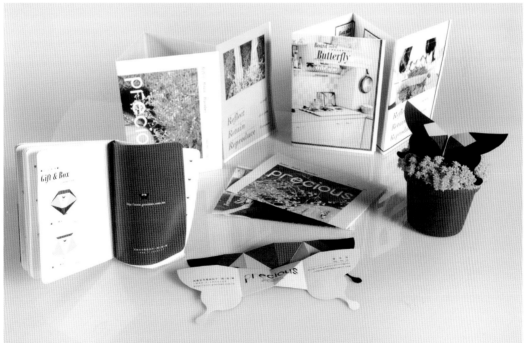

1	2
3	4

5

1. 品牌文宣I 4. 單品DM
2. 品牌文宣II 5. 文宣
3. 海報

1. Brand Publication I 4. Product DM
2. Brand Publication II 5. Publication
3. Poster

包裝設計
/ Packaging

在大盒及中盒包裝的部份，為配合主視覺的切割特色，運用切割造型來設計包裝。為使切割效果更明顯、質感更加突出，我們將蓋子設計成立體造型而非平整的蓋子。在製作過程中遇到許多問題，最後使用破壞性的做法使蓋子突出，為遮蓋摺痕則使用裱紙覆蓋。十二個裝(中盒)特別設計了兩層式的裝法，希望能營造出珠寶盒的氛圍。

As for the big and medium box packaging, to tie with the cutting characteristic of the main visual design, we use cutting shape to design the package. To make the cutting effect more visible, the texture more prominent, we design the lid into solid shape, not a flat one. We encounter many problems in the process. At last we use devastating methods to make the lid stand out, and cover with mounting plate to cover up signs of damage. We specially design the 12-Pack (medium box) in a two-tier boxed method, hoping to create a texture of jewelry box.

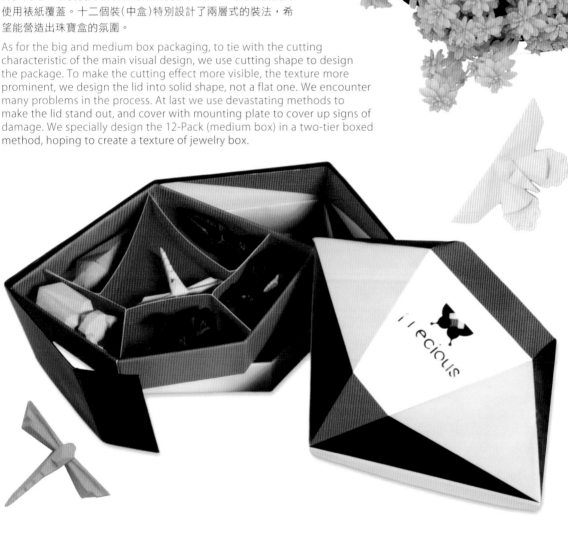

三入系列包裝 / 3-Pack Package

在小包裝的部分，考量到成本等問題，故於上蓋部份使用直接做出摺痕的做法來顯出立體感。依據不同的昆蟲所定出的標準色來設計盒子的顏色，擺放在一起時有如昆蟲珍寶們聚集之景況。

As for the small packages, consider the conditions such as cost, we make the crease directly on the cover to show the solid effect. Design the box color according to the standard set of each different insect. When put together, it looks like the treasured insects are gathered.

1	1. 三入系列包裝	1. 3-pack Package
2	2. 標準色	2. Color Plan
3	3. 產品與包裝	3. Products and Package

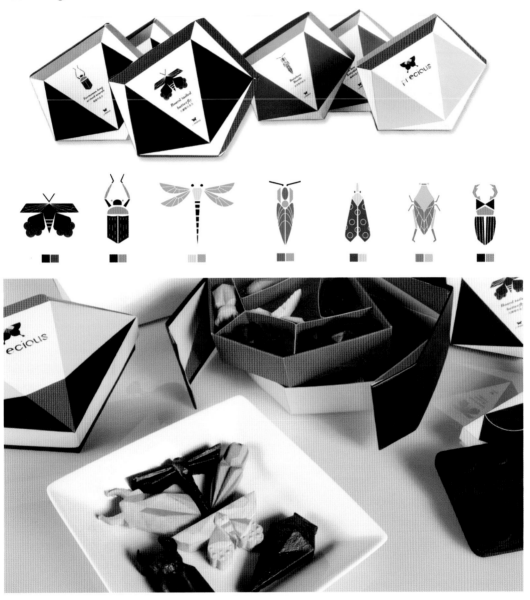

黎　薔 / Chiang Li

flickr.com/photos/cutie06018
cutie06018@hotmail.com

林宜玫 / Yi-Mei Lin

flickr.com/photos/yi_mei
trickster626@gmail.com

許孟涵 / Meng-Han Hsu

flickr.com/photos/j3610_nchan
xxxbellexxx2007@yahoo.com.tw

小巧的、方便的、輕鬆的、繽紛的、愉快的,希望能擺脫對「花茶」的既定印象,帶來不一樣的全新感受。

Compact, convenient, relaxing, colorful and pleasant,
we hope to get rid of the established impression of "herb tea".
Bring you a whole new sensation.

● 包裝設計 Packaging Design　　● 團隊 Team

包裝設計
／花花樂樂

Q：專題介紹

A：在對養生、健康的追求中，「泡茶」可被視為一種復古的趨勢，而花茶又是最受女性喜愛的類型。除了淡雅的色澤、香氣，更具有特殊的功效。於是乎，對現代生活繁忙的女性來說，一杯花茶，也許就是犒賞自己的小小奢侈。

目前在市面上尚未有小包裝的花茶，也因其取得之不便，在飲品市場占有率相當的低。因此，經過資料收集與分析之後，我們將商品定位為—推廣花茶。目標增加花茶普遍性，容易攜帶且隨處可購得的。

花茶是健康的、輕鬆的、令人愉悅的，而這種正面的能量可以經由花茶的香味、顏色、感覺，去獲得快樂，因此我們將品名定為—花花樂樂。

Q：製作此作品用的軟體是什麼，它如何將你們的設計發揮到極致？

A：使用Adobe Illustrator CS5來進行Logo及圖案的繪製，並利用Adobe Photoshop CS5對圖像的多變性來進行後續編修。

Q：請談談你們如何克服創作上遇到的瓶頸，也給對設計有興趣的讀者們一些建議？

A：和我們的設計理念、定位必須切題，而非單純的為了美而美，為了設計而設計。舉例來說，在盒型的部分，當我們的定位很明顯的是在便攜性、小包裝（一包一入價格不高）、隨處可得（便利商店）的情況下，那麼包裝就不宜繁雜厚重如禮盒，而應以較為輕便的方式去設計。設計是為了解決問題，而不是製造垃圾。

Packaging Design
/ Hua Hua Le Le

Q：Project introduction.

A：Brewing tea can be regarded as a retro tendency in the pursuit of health. The herb tea is most popular among the females. In addition to the elegant color and the slight fragrance, herb tea has many kinds of good effects to our health. Therefore, for the busy females in this modern society, a cup of herb tea might be a rewarding luxury.

At present, there is no small-packaged herb tea on the market, and it shares relatively low percentage of the beverage market because it is inconvenient to obtain.

Herb tea is healthy, relaxing and delightful. And these herb tea's positive energy can make people feel happy by smelling its fragrance, watching its color and tasting it. That's why we named our brand "Hua Hua Le Le."

Q：Which software did you use in this project? How did it help you bring out the best of your design?

A：We used Adobe Illustrator CS5 to make logo and draw patterns; Adobe Photoshop CS5 to edit the images according to their diversity.

Q：Please tell us how you overcame the difficulties during the project and give some suggestions to the readers who are interested in design.

A：We think it must be relevant to the subject with our design ideas and our orientation. Not just design simply for design's sake. For example, we oriented our package to be portable, small and available everywhere, so our package should not be complex and heavy like gift box. Instead, we designed it in a lighter way. Design is to solve the problems, rather than producing trash.

花花樂樂

創作動機
/ Motivation

在尋找主題時，我們從較實際的方向著手，思考著，什麼是被需要的，不那麼方便的。經過資料收集與討論之後，我們將方向定在花茶的個體包裝上。首先在收集資料的過程中發現，花茶大多以大包裝的形式出現，攜帶不易、便利性不夠及保存等等的問題造成花茶的普及度不佳；而比較茶類包裝後可以分類出大部分的茶類包裝風格偏向清淡、素面，較為傳統的感覺讓人對「泡茶」有了既定印象－年邁的、古板的。

因此，「花花樂樂」的定位在於小巧的、方便的、輕鬆的、繽紛的、愉快的，希望能擺脫對「茶」的既定印象，帶來不一樣的全新感受。

When looking for the theme, we proceeded from a more practical direction, thinking about what is needed and not so convenient. After collecting and analyzing the information, we orientated our commodities as the individual packaging of the herb tea. At the first stage of processing information, we discovered that the herb tea is sold with large packaging on the market. And it still has other problems like not easy to carry, the inconvenience to preserve, etc., making herb tea less popular. After comparing the tea packaging, we concluded that most tea packaging style is elegant and plain. So, the tea has established traditional and rigid impression on most people. Therefore, we named our theme as "Hua Hua Le Le." Its orientation is exquisite, convenient, relaxing, fun, happy and colorful, hoping to get rid of the stereotype of tea and bring a novel sensation.

目標對象
/ Target Object

台灣區飲料工業協會的數據資料顯示，花茶飲品占茶飲料業5%，並以二十至二十九歲年齡層為最高，因此我們結合四項動機：健康、享受、香味與色彩，主打女性上班族市場，同時兼具精緻感現代感，目標讓愛美的上班族輕輕鬆鬆就能喝出健康，興起一股健康下午茶風氣。

According to the data of Taiwan Beverage Industries Association, the herb tea accounts for 5 percent of the tea beverage market and customers are mostly in the age of 20 to 29. So we combined four motives: health, enjoyment, flavor and color, aiming the working female market. The office workers can obtain good health through drinking, with the exquisite and modern sense.

● 包裝設計 Packaging Design ● 製作過程 Production Process

製作過程
/ Production Process

標誌 / Logo

簡單而率性的線條，輔以鮮豔明亮的色塊來營造出輕鬆可愛的感覺。

The logo is made by hand-drawn lines, with bright colors to create a relaxing and lovely feeling.

花型 / Flower Shape

仔細觀察後，將寫實轉化成向量單位形，並以萬花筒的感覺將單位形經由旋轉、重疊，來完成每一種花型。

After the observation, we convert the realistic graphic to the vector unit shapes, and create each kind of flower shapes as kaleidoscope by rotating and overlapping.

色彩計劃 / Color Plan

以花朵本身的顏色為基礎，每個花型定出一個主色與兩個輔色來相互搭配。

Based on the colors of the flower itself, we define each flower shape as a primary color and two auxiliary colors.

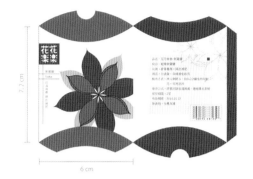

單體包裝 / Single Packaging

以方便輕巧為前提，使用派型做為單體包裝的盒型。

Convenience as the primary concept, we use the pie box as our packaging.

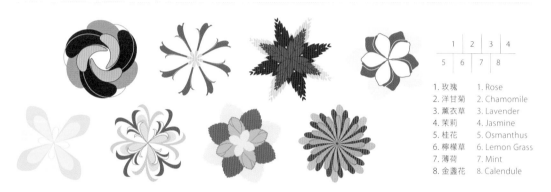

1	2	3	4
5	6	7	8

1. 玫瑰	1. Rose
2. 洋甘菊	2. Chamomile
3. 薰衣草	3. Lavender
4. 茉莉	4. Jasmine
5. 桂花	5. Osmanthus
6. 檸檬草	6. Lemon Grass
7. 薄荷	7. Mint
8. 金盞花	8. Calendule

示意圖 / Single Packaging

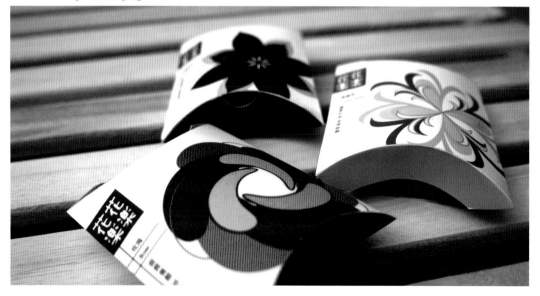

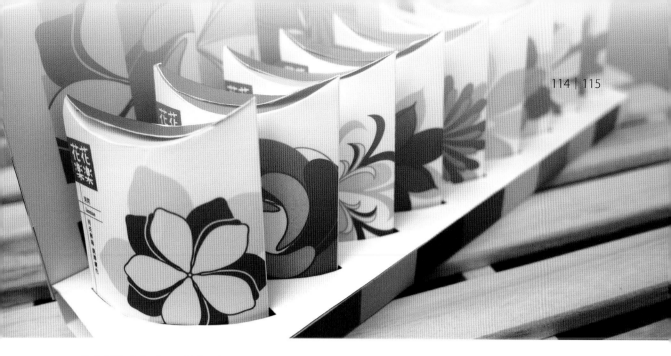

集合包裝 / Package Collection

將九品花茶以同樣風格的外包裝集合在一起，搭配令人愉悅的繽紛色彩。可作為送禮之選擇。

The nine kinds of herb tea are collected in the same style of packaging with pleasant colors. It may be a good choice for sending a gift.

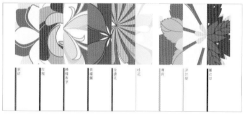

9 cm

26.7 cm

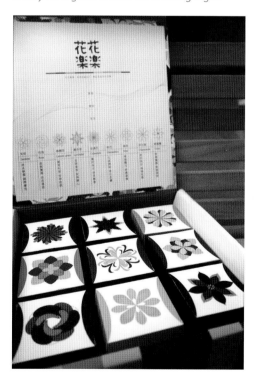

禮盒 / Gift Box

作為較正式的禮品組合，我們將長方體縮小成6公分高，並且以傳統茶葉較常出現的形式加上花型繽紛的配色，希望創造出正式卻也不失活力之感。

As a more formal gift set, we narrow the cuboid to 6 cm high in the form of general tea caddy and affiliate the flower shapes' colors. We hope to create a formal sense without losing vitality.

設計作品 Design Works ● 包裝設計 Packaging Design ●

杯墊 / Coasters

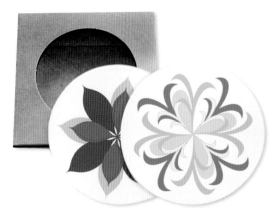

單純以花型直接壓印於陶瓷杯墊上，強調花朵造型及色彩，透過玻璃的折射營造萬花筒的感覺。

We emphasize the style and colors of flowers and stamp it on the ceramic coasters, hoping to create a kaleidoscope feeling through the glass refraction.

名片 / Business Cards

將花型解構，表達出「介紹」的意味。

We want to express the meaning of introduction by deconstructing the flower shapes.

茶包吊牌 / Teabag Tags

不強調花型，將其放大為滿版，主要希望以顏色來做品項的區分，呈現花朵的多樣化。

Instead of emphasizing the flower shape, we enlarge it to full version to show the flower's diversity and distinguish all the items in colors.

「花花樂樂」希望能藉由一杯小小的花茶，在繁忙的生活中，讓您感受到幸福的芬芳、甜美的清香。

We hope to let you feel lovely and sweet with "Hua Hua Le Le".

產品 / Products

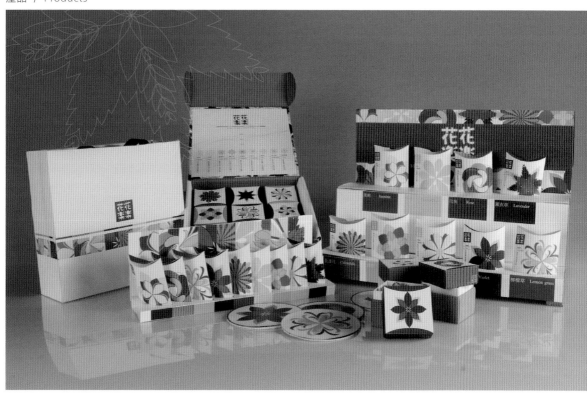

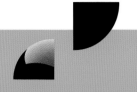
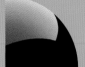
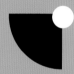

插畫設計
Illustration

Class of 2012
Department of Visual Design
National Kaohsiung Normal University

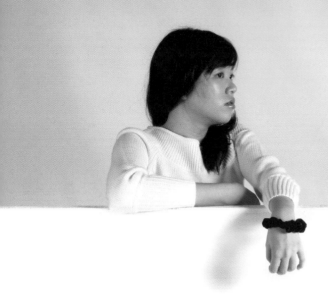

王黎臻 / Li-Chen Wang

flickr.com/photos/77274959@N02
erica889@ymail.com

在一個叫做鑲的奇幻國度，存在著許多傳說，
他們在這瑰麗的大地上，不斷地旅行與相遇。

A fantasy kingdom called Xiang, consisting of various legends.
Continuous traveling and encountering, they roam in this magnificent land.

● 插畫設計 Illustration ● 個人 Individual

插畫設計
/ Xiang Tales

Q：專題介紹

A：世界或許很大，也可能很小，而那些不斷地相遇與分離在記憶愈來愈淡之後，在遙遠的未來或許只能靠夢境追尋。這個夢境宛若七彩泡泡，一碰即碎，所以更要小心翼翼的收藏。這是一個架空的國家，藉由把美好的瞬間記錄下來的構想，去表現各種風情。

Q：製作此作品用的軟體是什麼，它如何將你的設計發揮到極致？

A：主要是使用Adobe Photoshop CS5、Sai和Painter，一張畫通常都會以這三個軟體交錯使用。我喜歡嘗試軟體間不同的筆刷與功能並置入紙材的質感，期望能找到一些不同並適合自己的上色方法。

Q：請談談你如何克服創作上遇到的瓶頸，也給對設計有興趣的讀者們一些建議？

A：音樂時常啟發自己很多靈感也為畫圖創造情境。出去走走或翻閱書籍，看影片也是很好的方式，先調整自己的心情。回到自己的作品上之後，如果某些地方表現不出來，就優先處理其他能夠處理的地方。

Q：畫圖時有沒有難以自拔的習慣，如何修正？

A：一直專注在一些可能不必要的小細節上，讓整個進度都慢了下來。後來發覺要適時放掉某些部分，讓目光能更聚焦在主體上，之後開始邊畫邊注意畫面的整體感，朝著這個方向努力。

Illustration
/ Xiang Tales

Q：Project introduction.

A：The world could be pretty big and broad, it also could be small and narrow. After our memories begin to fade away, those continuous encounters and separations could only be traced in dreams. To us, dreams are just like colorful bubbles; once you touch them, every precious dream could be shattered. Therefore, careful preservation is what these works aim for. This is a conceptual country, showing adventures from those characters in works with the idea of capturing every second of the brilliant moment.

Q：Which software did you use in this project? How did it help you bring out the best of your design?

A：I mainly used Adobe Photoshop CS5, Sai and Painter respectively during the drawing. I liked to try different painting brushes and functions between the software and put the texture of paper material into my works. I expected to find different coloring methods that are suitable for my style.

Q：Please tell us how you overcame the difficulties during the project and give some suggestions to the readers who are interested in design.

A：Music always creates different kinds of inspirations and atmosphere for me. Strolling the street, reading books and watching video clips are also good ways to adjust my mood. If there are still some parts that cannot be figured out, I would prioritize the parts that I already could handle.

Q：Do you have any habits that are so hard to quit when you are designing? How would you alter it?

A：Distracted by some nonessential details and causing entire progress to slow down. Afterwards, I find that sometimes I should let go of the parts that are subordinate to the main subject so that I could pay all my attention to the subject itself. While composing, I would examine the works as a whole, and work toward this aspect.

繪圖步驟
/ Drafting Process

在Photoshop開啟A3畫布，依腦內構思大略打彩色底稿。做人物及背景配置。將人物與背景分層描線。

Open the A3 scale of empty page in Photoshop, think and begin to draw colored draft. Dispose the characters and background. Line-drawing the layers of characters and background.

填好底色，決定光影。為了表現遠近感，近處使用較鮮明的顏色，遠處則用較淡的藍色調。在同一層圖層上色時可使用剪裁遮色片方便作業。

Fill in the background; decide the extent of light and shadow. To show the sense of distance, use the brighter and more vivid colors on the near objects/ scene. Contrarily, far objects/ scene with a lighter blue tone. In addition, when coloring on the same layer, it is more convenient to facilitate with Clipping Masks.

合併所有圖層，並在最上方開一個新圖層塗滿橘色，圖層屬性改為覆蓋。完成其餘背景部分並調整顏色。

Combine all the layers, and open a new layer on the top that is painted in orange. Also change the layer property from general to overlay. Complete the rest background, and adjust the colors.

筆刷設定實邊橢圓形15px。將線稿與底色圖層合併，一面注意光源方向一面描繪。所有的物件同時上色。龍鱗部分如圖，畫幾個不規則的圓，修飾稜角，圖形間的間距大致相同。

Set the brush shape to the size of oval 15px. Merge the lined draft and background layer together. Watch out for the light source while embarking on drawing, and then color all items. As for the dragon scales, draw a few irregular round shapes, and then modify edges and graphics. The spacing between each other should be roughly the same.

故事由進入森林開始，拜訪森林深處的稀少種族村落、參與其生活，並持續到各地旅行。一切看似沒有終點，但終究會成為回憶。

The story starts with the characters in the forest, visiting a rare race tribe in the deep woods, later, getting along with them. After a period of time, they continue the journey everywhere. It seems that there is no final destination, but all will become memories eventually.

圖為主角在旅途中所遇到的奇幻生物。

The picture shows the mysterious creature, which the characters encounter in the journey.

林中的休憩所 / The Rest Place in the Forest

孕育星星的地方 / The Place where the Stars are Born

人物設計 / Character Design

鳥族，非常稀有，具有幸運的象徵，會以自身生長
的羽毛來編織衣物，族群內大多為雌性。

The tribe of birds is very rare, with the symbol
of luck. They weave clothes with their own
feathers. The tribe is composed mostly of
female members.

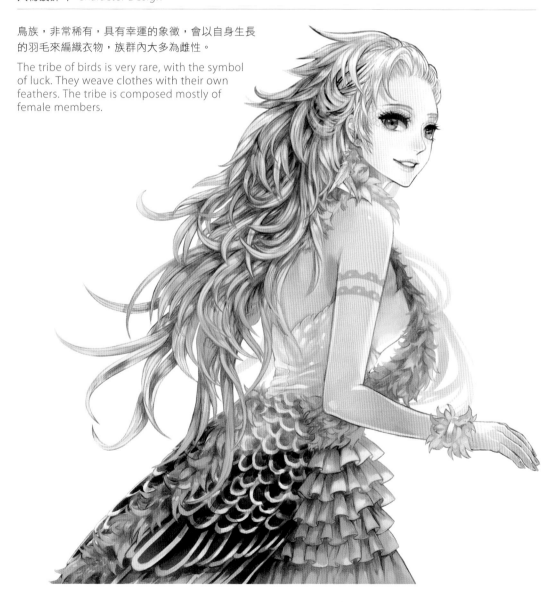

金恬綺 / Tien-Chi Chin

flickr.com/photos/victoriajin717/
svfcf1881@hotmail.com

DREAM
CATCHER

慾望和希望是一體兩面的東西，
當希望成真的時候，又要付出怎樣的代價呢？

Desire and hope are two sides of the same coin.
What is the price of making dreams come true?

 插畫設計 Illustration ● 個人 Individual

插畫設計
/ Dreamcatcher

Q：專題介紹

A：捕夢網是北美奧吉布瓦人的文化中一種手工藝品，使用柳樹來做框，中間編織著鬆散的網或蜘蛛網。奧吉布瓦人相信掛上捕夢網能夠捕捉好夢。而美好的夢境是怎麼來的呢？日有所思，夜有所夢。人們對慾望的渴求造就了希望這個詞，希望得到，希望擁有......，希望就是慾望的另一面，而以希望為名的追求會造成的以後正是我想表達的。

Q：製作此作品用的軟體是什麼，它如何將你的設計發揮到極致？

A：我以手繪的形式繪製圖像，工具是COPIC牌麥克筆C系列，原本打算呈現有色的圖像，不過繪製過後發現以單色更能呈現圖面的層次，所以改為單色上色，可能有人覺得單色會顯圖面無趣，所以我加強著整體感和前後關係的差距希望能使圖面豐富。而編輯方面使用Adobe Photoshop CS5和Adobe Illustrator CS5，用Adobe Photoshop CS5修正圖面然後用Adobe Illustrator CS5編排。

Q：請談談你如何克服創作上遇到的瓶頸，也給對設計有興趣的讀者們一些建議？

A：最大的瓶頸是如何以單一圖面說故事，希望讀者可以直接藉由圖面串聯故事。不過最終還是沒有達成，但是有把文字量減到最少了。

Q：設計時，有沒有難以自拔的習慣，你如何發現與修正？

A：資料收集上有些不足，所以時常畫到什麼才想到要去找資料參考，結果製圖時間就會被拖長，浪費了不少時間，應該要先收集大量資料統整、消化過後才開始繪製的。日後需要建立行程表才是。

Illustration
/ Dreamcatcher

Q：Project introduction.

A：Dreamcatcher is one of the handicrafts of North America Indian tribe Ojibwa. It used willows to make frame, and weaved a web in the middle. Ojibwa believed dreamcatcher can catch wonderful dreams. How do wonderful dreams come? The thoughts in the daytime will reflect in dreams at night. Humans create the word "hope" from their own desire. Hope is the other side of desire. All I wanted to express is the future which is pursued by the name of hope.

Q：Which software did you use in this project? How did it help you bring out the best of your design?

A：I drew illustration by hand and used marker (COPIC) — the series C. It's colorful in the beginning, but later I found that monochrome could bring out better gradation. Maybe some people think it is boring when it is monochrome, that is why I reinforced overall perception and the gap of contexts to enrich my illustration. I used Adobe Photoshop CS5 and Adobe Illustrator CS5 to modify and edit.

Q：Please tell us how you overcame the difficulties during the project and give some suggestions to the readers who are interested in design.

A：The biggest obstacle is how to tell a story from only one picture. In fact, the best way to show is a picture without words. I hope that readers can understand the whole story only by picture. Though the goal was in vain in the end, I did minimize the words in my story.

Q：Do you have any habits that are so hard to quit when you are designing? How would you alter it?

A：There is insufficiency in collecting information. So I usually do the collecting when I am designing. Therefore, I waste much time. I should collect much information and process it first before drawing. Setting schedule is also needed in the future.

概念發展
/ Development of Ideas

世上很多事情都是一體兩面的，
在獲得的同時，是否有注意過，我們失去了什麼？
Desire and hope are two sides of the same coin.
What is the price of making dreams come true?

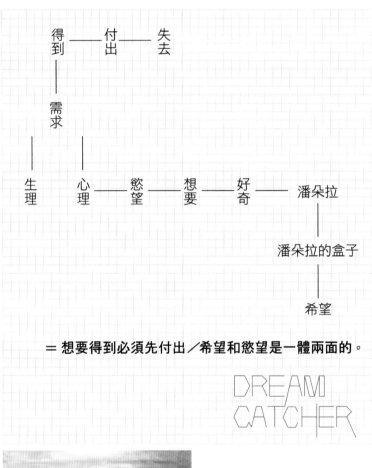

得到 ── 付出 ── 失去
│
需求
│
生理　心理 ── 慾望 ── 想要 ── 好奇 ── 潘朵拉
│
潘朵拉的盒子
│
希望

= 想要得到必須先付出／希望和慾望是一體兩面的。

DREAM
CATCHER

以麥克筆作為繪圖的選擇是因為麥克
筆可以呈現出如同照片一般的質感。

Markers can bring out the
photography-like texture.

麥克筆繪製
/ Marker Illustration

步驟：

1. 用鉛筆繪製出初步的形體，注意體感和透視。清除雜線。（註一）
2. 確認光線來源，使用代針筆將最深的部分上色。（註二）
3. 從C0至C5開始逐步做漸層，勿使亮部過黑。
4. 擴大漸層範圍後先用C6將暗部（陰影處）的範圍做出來。
5. 繪製暗部的光影變化後，和亮部做銜接。（註三）
6. 統整畫面光線走向。（註四）
7. 加入筆觸作為最後的修飾與體感。

註：

1. 過多雜線會使畫面過於凌亂，而且麥克筆畫過鉛筆線的話，事後會無法清除鉛筆線。
2. 最黑的部分必須最早下手，避免西卡紙吸附太多顏料後無法再上色。
3. 亮暗轉折的面積會影響體感。
4. 亮暗的銜接並非斷層，而是顏色間的延續，因為暗部最亮處會是亮部最暗處，反之亦同。

Steps:

1. Use pencil to sketch the basic form. Notice the volume and the perspective. Clear unwanted sketches. (Remark 1)
2. Confirm the light source. Use a needle pen to color the darkest area. (Remark 2)
3. Make the gradient color effect by using color C0 to C5, beware not to over-sketch the lighter areas, making them too dark.
4. Expand the gradually effect areas then use color C6 to illustrate shading area.
5. After illustrating the changes of shade in darker areas, make a junction with lighter areas. (Remark 3)
6. Unify the direction of light source. (Remark 4)
7. Add finishing touches for the final adjustment and volume.

Remark：

1. Too many unwanted sketches can cause untidiness. Once the marker runs over the pencil sketch, it would be impossible to clear the pencil lines.
2. Always start with the darkest areas in case the Bristol board absorbs too much (ink) and becomes unable to be colored.
3. The size of the joint area between the light and the shade will affect the volume of the illustration.
4. The joint area should not be gapped, instead it should be the continuality between colors, as the lightest part of the darker area would be the darkest part of the lighter area.

標準色 / Color Plan

繪製方面採用冷色調為主，所以標準色上選用了鐵鏽般的橘銅色和青銅色，希望能表現出過度發展下各種物品皆被削損至極的感覺。

Nowadays, everything has been over used due to the highly-expanding developments. The color plan for this illustration which was chosen to fulfill the image is the rusty orange copper and the green copper from the cool color tones.

● C 20 / M 75 / Y 60

● C 60 / M 60 / Y 90 / K 50

標誌 / Logo

以捕夢網的主要材料一線為主，搭配標準色的使用，在平面上做出連結，呈現出如同捕夢網一般的網面。

The key element of "Dreamcather "is the lines, coordinated with the use of color plan, to make connections on two-dimensional surfaces. The purpose is to present a net effect similar to dreamcatchers.

書籤 / Bookmarks

以繪本內容為主，不做過度綴飾。

Design the bookmarks by using the pictures in the book, with no decoration.

內頁 / Pages

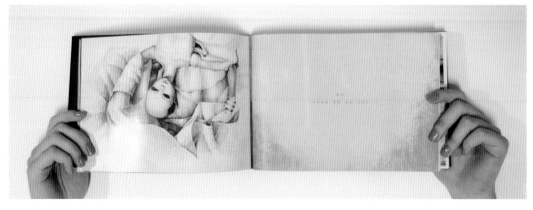

周邊商品 / Merchandise

運用既有的圖像搭配出和繪本內容有呼應的一系列周邊
商品，希望能和觀眾產生互動性。

A Series of related products designed from the
image and the contents of sketch book are made
to provide better interactions with the viewers.

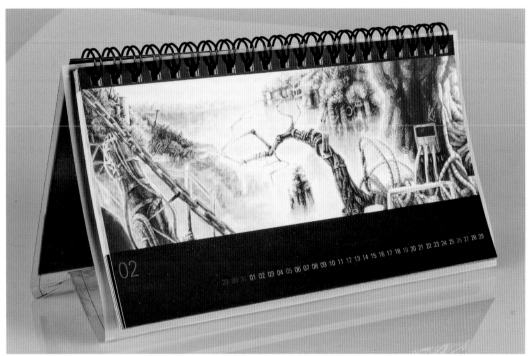

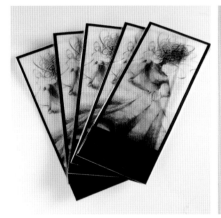

年曆 / Calendar

以Logo為封面製作出來的小本年曆，可以作為隨身攜帶的記事筆記，又可作為宣傳品。

A calendar book, with the logo as the cover page, is made to be a notebook for carrying around as well as a PR product.

名片 / Business Card

以標準色搭配為主，不做過度綴飾，簡單明確的傳遞訊息。

The color plan as main tone, without over decoration, to convey the message clearly.

卡片 / Card

以標準色搭配為主，不做過度綴飾，簡單明確的傳遞訊息。

The color plan as main tone, without over decoration, to convey the message clearly.

分鏡 / Storyboards

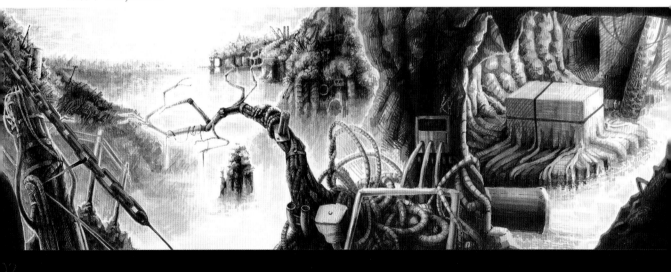

潘朵拉的盒子還是被發現了，
在雲裡，在海裡，在山裡。

DREAM
CATCH

● 插畫設計 Illustration　　● 設計作品 Design Works

材質應用 / Material Application

為呼應繪本內既有的科技感和頹廢感，使用了鐵金屬等等既冰冷又無人性的媒介製作捕夢網。

Iron and other cold metals are also used to make Dreamcatcher in response to the presentation of hi-tech and dispirited images in the sketch book.

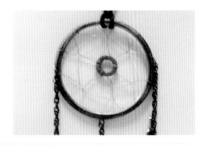

海報 / Posters

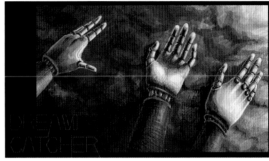

展場設計 / Exhibition Design

以標準色為主，使用兩種不同的布料作為背景配置，並且加入微弱的燈光，造成若隱若現的空間感。

Two different types of materials are set to be the background, with a touch of weak light to create a sense of space that is partly visible and partly hidden.

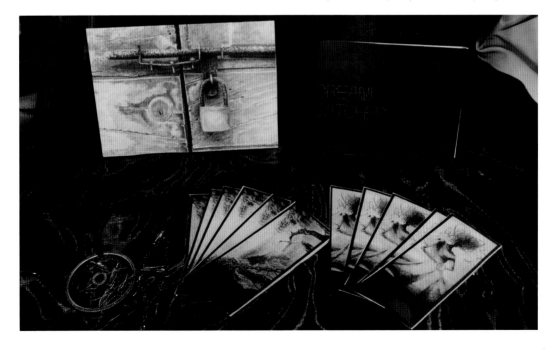

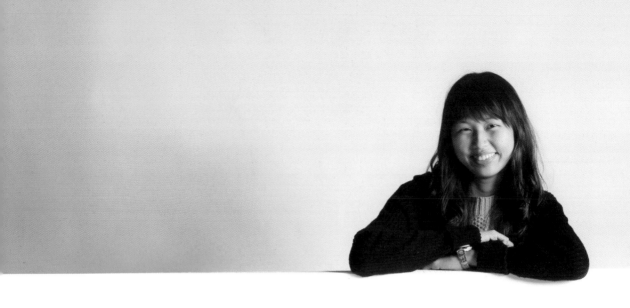

李昭儀 / Chao-Yi Li

http://www.facebook.com/chaoyi.lee
pb221136@hotmail.com

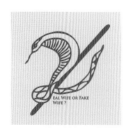

傳統與現代的對話，回溫來自古來的
民間傳說，現實與虛假間求融合。

Dialogue between traditional and modern.
Renewed from the ancient folklore,
seeking integration between the reality and the fabrication.

● 插畫設計 Illustration　　● 個人 Individual

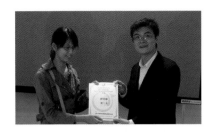

插畫設計
/ 是玉蓉還是玉鳳

Q：專題介紹

A：劇情參照文學小說的手法布局，以民間傳說「蛇郎君」為藍本，改寫而成的短篇小說。「蛇郎君」的劇情類似西方的「美女與野獸」，但「是玉蓉還是玉鳳」劇情結局與原著大有不同，是一個經作者全新改寫而成的故事。如英文字面上翻譯 "Real Wife or FakeWife"一真假妻子。樵夫之女改成二位雙胞胎姊妹，妹妹玉蓉嫁給蛇郎君，姐姐玉鳳得知妹妹玉蓉享盡榮華富貴（蛇郎君家境富有且夜間會變成一位俊美的男子），姊姊見不得其好，會使用什麼樣的手段奪走妹妹的幸福？而劇中男主角旭白（玉蓉的兒子）又是如何解開這一切的疑雲？本故事將一般的民間故事改為懸疑性的短篇小說，一筆一畫的繪製繪本的每一個細節，希望可以透過這個故事，帶給讀者視覺上的感動。

Q：製作此作品用的軟體是什麼，它如何將你的設計發揮到極致？

A：主要用Adobe CS Master。如Adobe Indesign CS5可以進行繪本書籍編輯；Adobe Photoshop CS5可以進行繪製以及合成素材。

Q：請談談你如何克服創作上遇到的瓶頸，也給對設計有興趣的讀者們一些建議？

A：多多看國內外插畫家的作品或是出遊尋求靈感。建議學子們可透過平時多看電影、文學名著、繪本、dpi雜誌，從中取得靈感或許會有意想不到的收穫。

Q：你有欣賞的設計師或藝術家嗎？他們對你的影響為何？

A：我很欣賞畢卡索，有人說我的畫風和畢卡索有一些相像的地方，畢卡索給我的啟發在於畫面的構圖，分割、拉長比例和平面化的壓縮。

Illustration
/ Real Wife or Fake Wife ?

Q：Project introduction.

A：The Picture book "Real Wife or Fake Wife ?" is in tones of pink and golden copper in order to create a retro atmosphere."Real Wife or Fake Wife ?" is rewritten from the Chinese ancient folklore "Snake Husband." " Snake Husband" is somewhat similar to the Western "Beauty and the Beast" but "Real Wife or Fake Wife" is very different from the original. Literally translated into English, "Real Wife or Fake Wife" means - true or false wife. Once upon a time, in ancient Taiwan, there is a woodman who has two twin daughters. Younger sister Yurong marries to Snake (snake-shaped by day, Snake would become a rich and handsome man by night). The elder sister Yufeng is jealous of her, and she schemes to take away everything from Yurong. What will happen next? And how would Fan Bai Xu (Yurong's son) unlock all the mystery? Through this story, I hope that readers could be touched by the visual sensation, and re-examine the folk lore.

Q：Which software did you use in this project? How did it help you bring out the best of your design?

A：I mainly used Adobe CS Master. For example, I used Indesign for book editing, and Adobe Photoshop CS5 for drawing, and material synthesizing.

Q：Please tell us how you overcame the difficulties during the project and give some suggestions to the readers who are interested in design.

A：Observe more domestic and foreign illustrators' works. Travel to get inspiration. I recommend that the readers can expose themselves to different kinds of movies, literature, picture books, from which you can get unexpected results.

Q：Do you have any favorite designer or artist? How do they inspire you ?

A：I really like Picasso, some people say my style is similar to his. Picasso gives me some inspirations which lay in the composition of the screen, splitting, elongated proportions and planar compression.

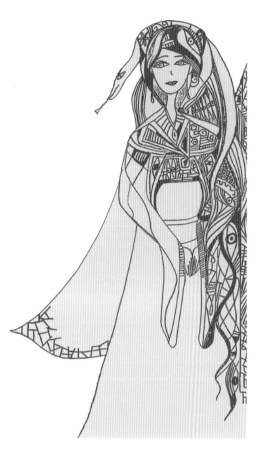

創作流程
/ Creation Procedure

以民間傳說蛇郎君原著為藍本，加以改寫而成。運用手繪結合電繪的方式呈現精緻理性而富有感情的線條。用0.5中性筆打完底稿後進入電腦修改和繪製其細節。

Rewritten from folklore "The Snake Husband", the combination of computer graphics and hand-painting present exquisitely rational and emotional lines. The author uses the 0.5 Gel pen to draft before she puts the works into the computer to modify and draw the details.

下圖由左而右依序是繪圖演進過程，人物造型透過簡化發展。海浪參考中國古代海浪畫法。

The following from left to right is the drafting process.
The characters developed through simplification. The waves of painting are referred to the waves of traditional Chinese painting.

軟體應用
/ Adobe CS Master

利用基本內建筆刷工具繪製。背景可開圖層使用合成效果，亦可利用橡皮擦工具將背景合成圖紋增加其精緻度與完整性。

Open the background layer to synthetic. Use the basic built-in brush tool to draw. Utilize the eraser tool to increase the background synthesis pattern, adding the delicacy and completeness.

運用Indesign編輯書籍文字與圖。
We can use the Adobe Indesign to edit book.

新版本的Indesign可轉存成Flash電子書，富有其便利性。

The new version of Indesign can be transferred into e-book which is rich in convenience.

繪本企劃
/ Picture Book's Project

繪本的製作企劃不僅可以保存繪本的創作歷程也可以更加完善的創作出一本完整且正式的繪本。步驟如下八大步驟後續一一介紹。

The picture book's project not only can preserve the creation steps of the picture book, but also can make it more complete and formal.
The following are eight detailed steps:

族群設定 / Positioning

繪本的創作要給哪個族群閱讀？針對族群進而繕寫劇情內容。/ 此繪本作品是設定給一般社會大眾。

What is the readers' level that the picture book aims? / The story is written for the general public.

故事編寫 / Story

故事的來源以及歷史，可蒐集相關文獻考據資料發想。/ 此作品劇情參照文學小說的手法，以民間傳說蛇郎君為藍本加以改寫而成。

We can collect the relevant references for the inspiration of the story sources and history. / The storyline of this work follows the literary novel techniques, and is rewritten from folklore "The Snake Husband."

族群設定 Positioning
↓
故事編寫 Story
↓
平時速寫 Live Sketch
↓
草圖繪製 Sketch
↓
色彩計劃 Color Plan
↓
圖片蒐集 Research
↓
版面配置 Layout
↓
完成稿件 Final
↓
周邊商品 Merchandise

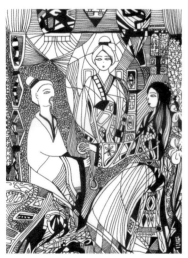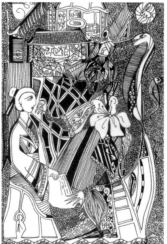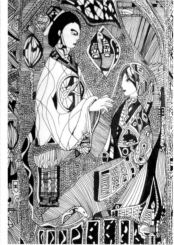

平時速寫 / Live Sketch

確立風格。/ 此作品角色造型以古代人物和文物與自我繪畫風格結合。

To establish your own painting style. / The characters in this picture book are formed by the combination of ancient figures or antiques and the author's own painting style.

草圖繪製 / Sketch

分鏡構圖與試畫。可用電腦或是鉛筆繪製草圖。/ 此作品作者使用黑筆勾邊緣，增加線條之流暢度。

Storyboard composition and painting attempts. Use computer or pencil to sketch. / The author uses the black 0.5 Gel pen to depict edges, and adds the fluency of the lines.

作者的觀點為「手繪是繪畫的基礎，電腦繪圖是輔助工具。」

The author's point of view: "hand -painting is the basis; computer is the auxiliary".

色彩計劃 / Color Plan

繪本的色調是精髓，色彩的節奏會影響到繪本的閱讀性。/ 此作品為單色，以淡紅和銅色或金色為主色源，營造古代復古氣息。

The essence of the picture book is the color tone. The colors will influence the readability. / Monochrome pink and copper or gold as the color source to create the atmosphere of ancientry.

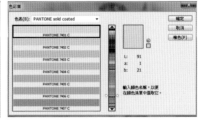

● PANTONE 702 C ○ PANTONE 7401 C

圖片蒐集 / Research

可從報章雜誌、網路照片或是電影畫面擷取和平常家人或同學的互動找尋自己想要的畫面和人物的動作以便創作時構圖之參考。/ 此作品開場白是以吸血鬼的概念創作而成。

We can collect from newspapers, magazines, Internet photos or movie screen capture, and also the daily interaction with friends and family to find the images or actions for the future references. / The opening of this work is composed with the concept of vampires.

版面配置 / Layout

可透過Indesign進行圖文配置，多樣嘗試字體，找尋最適合自己的畫風之字體。/ 作者選擇符合畫風的仿宋體，結合復古的氣氛。

We can use the Adobe Indesign CS5 to do the graphic configuration, or try different fonts, and find the most suitable to your own style. / The author chooses the font of FangSong, combined with the retro air.

完成稿件 / Final

作品可拿給對插畫有研究的學者或是插畫家討論，和投稿相關之繪本競賽。/ 此作品有詢問國內當代插畫家的建議。

We can also discuss the work with other professionals or illustrators. / This work was asked for suggestions from the domestic contemporary illustrators.

	2	1. 繪本內頁	1. Picture Book
1	---	2. 卡片設計	2. Envelopes and Cards
	3	3. 信封與卡片設計應用	3. Postcards

● 插畫設計 Illustration　　● 設計作品 Design Works

周邊商品 / Merchandise

利用繪本中既有的元素圖片延伸發展成一系列的周邊商品，
可以讓讀者當成書籤或是寄出明信片傳遞內心的祝福。

We can use the elements in the picture book to develop
into a series of products. Readers can use the merchandise,
such as the bookmark or the postcards to send their
blessing to their friends or lovers.

4	
5	6

4. 明信片設計
5. 繪本成品與周邊商品
6. 筆記本設計

4. Postcards
5. Book and Merchandise
6. Notebook Design

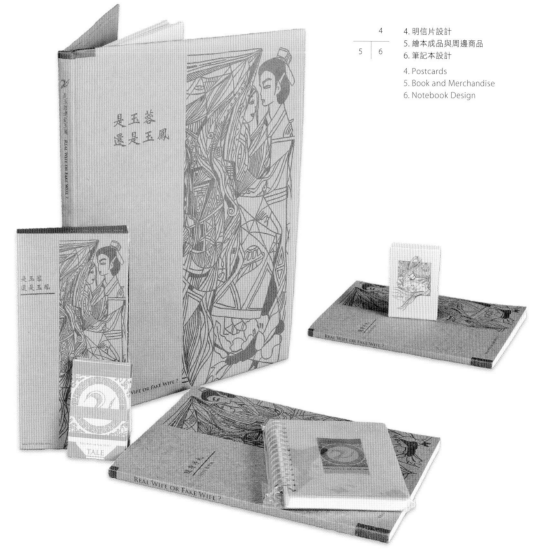

蔡京喬 / Ching-Chiao Tsai

flickr.com/photos/iwtwooo
iwtwooo@gmail.com

一個動盪不安的時代，一座冰封在國境邊界
的城關，記錄著一場淹沒在雨雪中的戰役。

A turbulent era. A city ice-bound at the country border.
Record of a battle submerged in rain and blizzards.

插畫設計
／城關迴雪

Q：專題介紹
A：以圖為主文字為輔的繪本畫冊，主要內容以呈現「一個時代的生活背景與當時的世界觀」為主軸，背景設定是以中國古代為參考基準的架空世界。

Q：製作此作品用的軟體是什麼，它如何將你的設計發揮到極致？
A：以手繪為主，使用水彩與素描作畫，之後掃描進電腦再用Adobe Photoshop CS5調整畫面色調與修邊作業。

Q：請談談你如何克服創作上遇到的瓶頸，請給想進入插畫界的後輩一些建議？
A：就目前來說本人因為還有極大的進步空間，連瓶子都沒有，所以沒有瓶頸問題。不過還是建議想走這條路的人要好好打穩繪畫基礎，然後再畫一張圖之前仔細想想自己想畫這張圖是想要傳達什麼？還有就是要多觀察生活周遭的事物以及多觀看別人的作品，不要讓自己的腦袋停滯不前。

Q：從事插畫創作時，有沒有難以自拔的習慣，如何發現與修正？
A：習慣在繪圖過程中仔細刻畫不重要部位的畫面，導致圖畫的重點失焦或是畫面雜亂導致圖畫的層次感出不來。每次發現問題時都已經幾乎完稿，所以要修正此問題就必須在畫下一張圖時，要先全部在腦中模擬一次繪畫過程，預想過完稿畫面再開始畫。

Illustration
/ City Wall with Snow

Q : Project introduction.
A : This is a picture book album focusing mainly on pictures and accompanied by words. The content presents " the living background and world view of that era." The settings are based on a fabricated world in ancient China.

Q : Which software did you use in this project? How did it help you bring out the best of your design?
A : I used sketch pens and watercolor to compose my works. Then I used Adobe Photoshop CS5 to adjust the hues of the painting and to fine-tune it.

Q : Please tell us how you overcame the difficulties during the project and give some suggestions to the readers who are interested in design.
A : To be honest, there is still room for me to improve. In other words, how can there be any bottlenecks if there is no "bottle" at all? However, if you want to enter this profession, the priority is to build up the foundation of drawing. Then before you draw a picture, think twice about what you want to express. In addition, try your best to observe everything around you and to appreciate others' works. Do not let your brain stay stagnant.

Q : Do you have any habits that are so hard to quit when you are designing? How would you alter it?
A : During the drawing, I usually care too much about unnecessary parts. That causes many problems such as the work becomes out of focus, or lack of gradation due to the disorderly tableau. Most of the time, the problems are detected when I almost complete the work. If I want to solve the problems, I should consider simulating overall drawing course before getting down to drawing.

繪本概念
/ Concept

故事背景設定是以中國古代為參考基準架空 The settings of story are based on a
的幻想世界，內容以軍隊生活為主軸，紀錄 fabricated world in ancient China.
一場戰役的始末。 The content focuses on troop's life,
recording a battle from the start to the end.

構圖發想
/ Development of Composition

首先構思好想畫的故事片段，接著找實際參 First, conceive the storyline. After that,
考資料，然後才畫出草圖。之後仔細精稿。 find the related references to use in
drawing the draft, and then finish the
picture carefully.

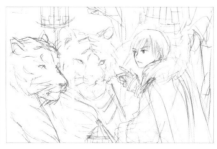
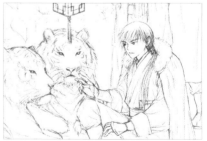

繪圖過程
/ Drafting Process

畫完鉛筆稿之後，首先使用代針筆上墨線，記得適度留黑。接著在上色之前，先在腦中預先設想好大致上的顏色配置。

一開始先用淡彩暈染環境色，然後從畫面上的主要角色開始上色。

畫完主要角色後，接著使用縫合、重疊、渲染等水彩技法去完成背景，記得要讓前、中、遠景分出層次。

最後再把整張圖的顏色做微調，在畫面主要部分補上燈光的顏色以及周圍反射的顏色。

After finishing the pencil composition, first use substitute needle pen to trace image with black ink. Remember to remain black moderately. Before coloring, think of all the colors in this image in advance.

At first, use light colors dyed for the environment tone. Then start painting from main characters. After finishing the main part, use stitching up, overlapping and dyeing of watercolor techniques to accomplish the painting. Remember to separate view levels of distances.

Finally, adjust color tones and make up the colors which reflect light in environment of painting.

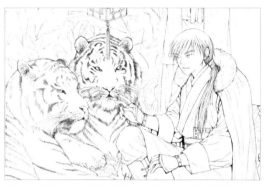

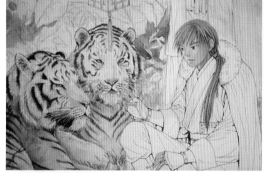

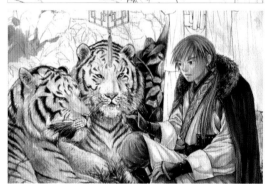

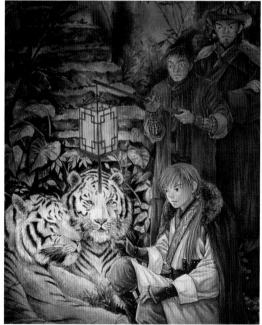

1	2
3	
	4

1. 過程一　1. Step1.
2. 過程二　2. Step2.
3. 過程三　3. Step3.
4. 完稿　　4. Final

標誌　/ Logo

使用軍旗上的徽章做為代表標誌。圖案以老鷹為設計的基本圖樣,設計概念源由來自故事內部設定。

The logo is from the badge of army flag. This image is based on the pattern of an eagle, which is sourced from story settings.

故事背景設定 / Background Settings

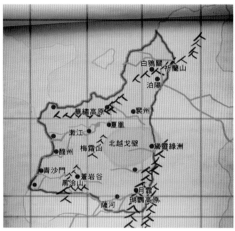

1 | 2

1. 世界地圖　　1. The World Map
2. 國家地圖　　2. Dynasty Territory Map

主要角色 / Main Characters

故事大綱 / Script

1. 東北大關泊陽城　　1. The walled city at Northeast – Sun Lake.
2. 白鴉關飲酒論道　　2. Conversation at White Owl border checkpoint.
3. 南下路過緗壁崖　　3. Going southward pass through yellow cliff.
4. 營帳內戰術討論　　4. Discussing tactics on topography in camp.
5. 黎明之前的談判　　5. The negotiations before daybreak.

1	2
3	5
4	

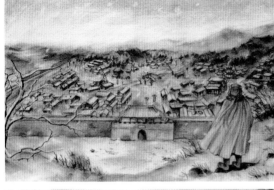

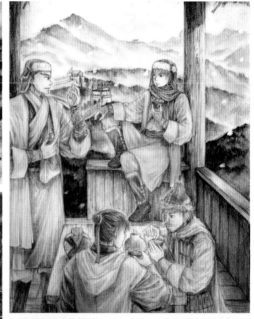

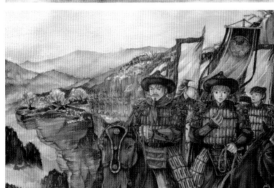

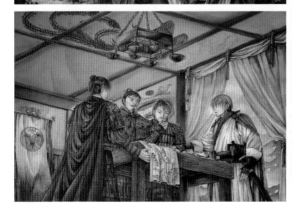

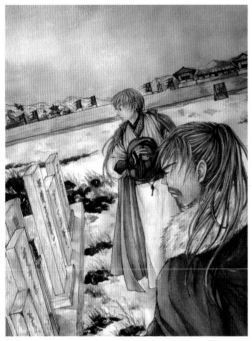
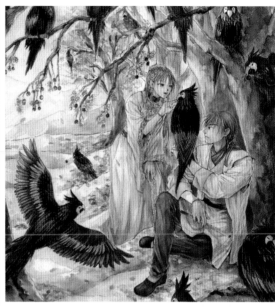

9. 悼念戰亡軍之靈　　9. Mourning for the fallen soldiers' spirits.
10. 回鄉後的賞鸚遊　　10. Returning to homeland to meet family on vacation.

9 | 10

周邊商品 / Merchandise

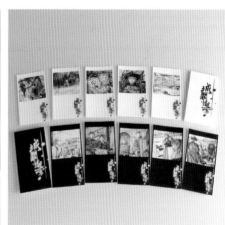

1. 手製公仔　　1. Handmade Doll
2. 畫卷掛軸　　2. Hanging Scroll Painting
3. 書卡　　　　3. Bookmark

1 | 2 | 3

設計群 / Designers

劉醇涵　Chun-Han Liou　　　　陳逸芸　Yi-Yun Chen
邱昱瑄　Yu-Hsuan Chiu　　　　陳南瑾　Nan-Jin Chen
紀　薇　Wei Chi　　　　　　　林世豐　Shi-feng Lin
李欣穎　Shin-Ying Lee　　　　林宜玫　Yi-Mei Lin
黎　薔　Chiang Li　　　　　　蔡京喬　Ching-Chiao Tsai
陳威霖　Wei-Lin Chen　　　　江秉穆　Bing-Mu Chiang
林雅瑩　Ya-Ying Lin　　　　　楊雅婷　Ya-Ting Yang
王慈婉　Cih-Wan Wang　　　　陳奕仲　Yi-Chung Chen
陳孟慈　Meng-Tzu Chen　　　　江芃瑾　Peng-Jin Chiang
王藜臻　Li-Chen Wang　　　　許孟涵　Meng-Han Hsu
尤敏芳　Min-Fang Yu　　　　　陳　琳　Lin Chen
楊絮涵　Shu-Han Yang　　　　閻柏柔　Pao-Jou Yen
李昭儀　Chao-Yi Li　　　　　王靜雯　Ching-Wen Wang
金恬綺　Tien-Chi Chin　　　　陳淑鈺　Shu-Yu Chen
朱冠蓁　Guan-Zhen Zhu　　　　王興喬　Xing-Qiao Wang
蔡孟珊　Meng-Shan Tsai　　　　李曉菁　Xiao-cyanine Lee
曾安佳　An-Jia Tzeng　　　　張瓊文　Chiung-Wen Chang
陳羿希　Yi-Hsi Chen　　　　　詹雯婷　Wen-Ting Chan
　　　　　　　　　　　　　　邱豐雄　Feng-Hsiung Chi

Class of 2012
Department of Visual Design
National Kaohsiung Normal University

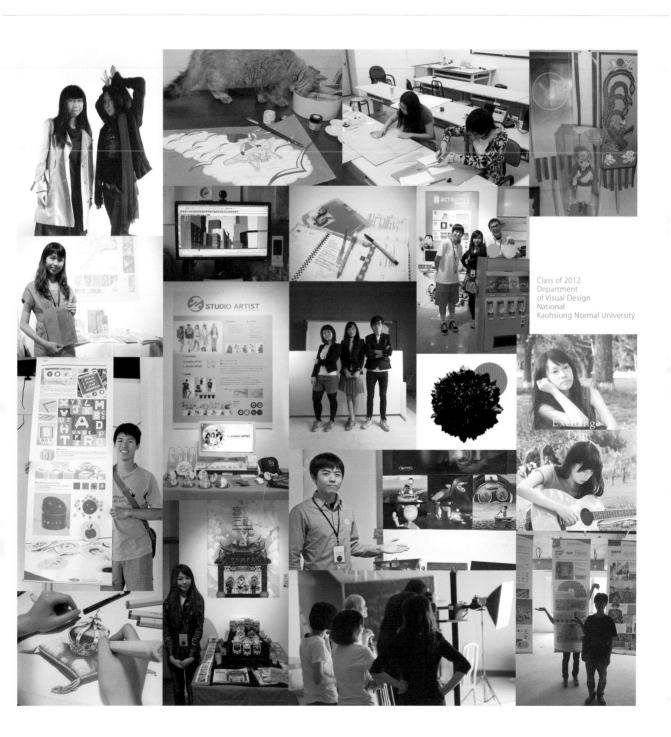

Class of 2012
Department
of Visual Design
National
Kaohsiung Normal University

國家圖書館出版品預行編目(CIP)資料

設計現場：不可不知的設計17招 / 高雄師範大學視覺
　　設計系第三屆畢業生作. -- 初版. -- 新北市：新一代
　　圖書, 2012.06
　　　　面；　公分
　　ISBN 978-986-6142-24-6(平裝)

　　1.視覺設計　2.作品集

　　960　　　　　　　　　　　　　　101008244

設計現場 / 不可不知的設計17招
Design on Location / Must-Know 17 Tips in Design

總　編　輯：洪明宏
藝術顧問：林維俞　蔡頌德
作　　者：高雄師範大學視覺設計系　第三屆畢業生
形象規劃：紀　薇　陳威霖　陳羿希　陳逸芸　閻柏柔
美術編輯：閻柏柔
英文校稿：吳宛真

發　行　人：顏士傑
編輯顧問：林行健
資深顧問：陳寬祐
出　版　者：新一代圖書有限公司
地　　址：新北市中和區中正路906號3樓
郵政劃撥：50078231新一代圖書有限公司
電　　話：(02)2226-3121
傳　　真：(02)2226-3123
經　銷　商：北星文化事業有限公司
地　　址：新北市永和區中正路456號B1
電　　話：(02)2922-9000
傳　　真：(02)2922-9041
印　　刷：五洲彩色製版印刷股份有限公司

定　　價：新台幣420元整